Encounters
with Rauschenberg

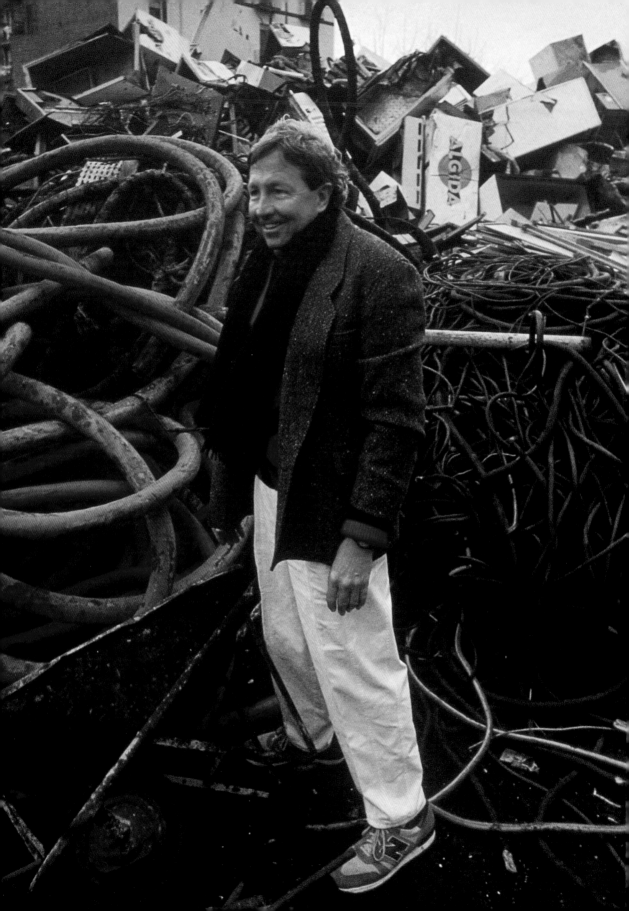

Encounters
with Rauschenberg

(A Lavishly Illustrated Lecture)

Leo Steinberg

THE MENIL COLLECTION
Houston

THE UNIVERSITY OF CHICAGO PRESS
Chicago and London

I have left this lecture largely as delivered and have not purged it of quips and by-blows which listeners to a live speaker are more likely to tolerate than readers of cold print. —L. S.

The lecture was presented at the Solomon R. Guggenheim Museum, New York (October 21, 1997) and, with revisions, for The Menil Collection, Houston (May 7, 1998), on the occasion of "Robert Rauschenberg: A Retrospective." For this publication, the text has been slightly augmented. The retrospective, organized by the Solomon R. Guggenheim Museum and curated by Walter Hopps and Susan Davidson, traveled from New York to Houston, Cologne, and Bilbao from September 1997 to March 1999.

Note: All artworks illustrated are by Robert Rauschenberg unless otherwise indicated. Descriptive identifications not given by the artist appear within brackets.

Cover: *The Ancient Incident (Kabal American Zephyr),* 1981 (see Fig. 51).
Frontispiece: Rauschenberg in junkyard, Naples, Italy, December 1987

The University of Chicago Press. Chicago 60637

The University of Chicago Press, Ltd., London

Copyright © 2000 Menil Foundation, Inc. Published 2000.
1519 Branard, Houston, Texas 77006
All rights reserved.

Artworks by Jasper Johns © Jasper Johns/Licensed by VAGA, New York, N.Y.
Artworks by Willem de Kooning © 2000 Willem de Kooning Revocable Trust/
 Artists Rights Society (ARS), New York, N.Y.
Artwork by Jannis Kounellis © 2000 Jannis Kounellis
Artworks by Robert Rauschenberg © Untitled Press, Inc./
 Licensed by VAGA, New York, N.Y.

Printed in Germany

09 08 07 06 05 04 03 02 01 00 1 2 3 4 5

ISBN: 0-226-77182-2 (cloth)
ISBN: 0-226-77183-0 (paper)

Library of Congress Cataloging-in-Publication Data

Steinberg, Leo, 1920–
 Encounters with Rauschenberg : (a lavishly illustrated lecture) / Leo Steinberg.
 p. cm.
 Includes bibliographical references.
 ISBN 0-226-77182-2 (alk. paper) — ISBN 0-226-77183-0 (pbk. : alk. paper)
 1. Rauschenberg, Robert, 1925—Criticism and interpretation. 2. Steinberg, Leo,
 1920—Anecdotes. I. Rauschenberg, Robert, 1925– II. Title

N6537.R27 S74 1999
700'.92–dc21
 99-059975

This book is printed on acid-free paper.

Contents

Foreword and Acknowledgments

In 1995, we were invited by the Solomon R. Guggenheim Museum to curate a major retrospective on the work of Robert Rauschenberg—one of this century's most influential living artists. In the process of devising an educational program, we decided against enlisting a group of respected scholars to scrutinize Rauschenberg's expansive career in a symposium format. We sought instead a single speaker of prodigious eminence—Leo Steinberg. Steinberg has examined and written about Rauschenberg's art (though as he admits with some significant gaps) since the artist's second one-person exhibition at the Charles Egan Gallery in 1954. Steinberg had last lectured on Rauschenberg in 1968 at The Museum of Modern Art; that lecture, greatly expanded and reworked, was the genesis of his pivotal essay entitled "Other Criteria," which debunked Clement Greenberg and recognized a new vocabulary in the work of Rauschenberg.

Initially reluctant to accept our invitation, Steinberg finally agreed to take the podium and bring a fresh eye to Rauschenberg's art. Within a simple structure of highly personal reminiscences, Steinberg tackled the import of several of Rauschenberg's seminal works, including *Erased de Kooning Drawing, Bed,* and *Monogram* and then responded to more recent works on view in the retrospective. After hearing the lecture in New York, we were hopeful that Steinberg would agree to present it again in Houston. Another impetus for bringing Steinberg to Houston was to pay tribute to Dominique de Menil who had recently passed away in December 1997. Over the course of three decades John and Dominique de Menil had invited Steinberg to Houston for a number of lively and avidly attended lectures on artists as diverse as Michelangelo and Picasso.

The second presentation of "Encounters with Rauschenberg," delivered one spring night in Houston, was without question a success, and we realized that it deserved to be heard by a much wider audience than the one that packed the auditorium at the Museum of Fine Arts, Houston. Certainly we are not the first to host Steinberg and wish that the lecture we heard could be more widely disseminated. However, setting aside those talks that were

seeds for greatly expanded published works, this is the first occasion in Steinberg's illustrious career where circumstances converged to make possible the publication of a lecture, essentially intact as delivered. This is in part possible because of the conversational framework of the presentation. Readers, unburdened by the demands of the rapid-fire delivery necessitated by a ninety-minute format, will gain the advantage of savoring Steinberg's remarkable command of language and his inimitable wit. They will also recognize, despite its somewhat informal packaging, Steinberg's trademark ability to peel away the detours and obstacles of previous critical thought and reveal essential and original truths.

Susan Bielstein, senior editor at the University of Chicago Press who has previously worked with Steinberg, immediately understood the importance of publishing a new piece of Steinberg criticism on contemporary art. She proposed a joint publication, an idea that former director Paul Winkler and the board of directors of the Menil Foundation readily accepted. Sheila Schwartz has been a capable collaborator in every phase of this work. David White, Rauschenberg's curator; Bradley Jeffries; and Denise LeBeau have provided their usual careful attention to our many requests. Geraldine Aramanda has adeptly secured all the photographic material presented in the lecture (along with some supplementary illustrations). Don Quaintance, who designed the Guggenheim retrospective catalogue, has brought his enthusiasm and his expert design capabilities to this endeavor. We are grateful to Thomas Krens, Lisa Dennison, Anthony Calnek, and Julia Blaut of the Guggenheim Museum, all of whom have lent their support to the realization of this publication.

Finally, we wish to express our thanks to Robert Rauschenberg, who offered his full encouragement for publication of Steinberg's engrossing and heartfelt treatment of his work.

—*Walter Hopps and Susan Davidson*

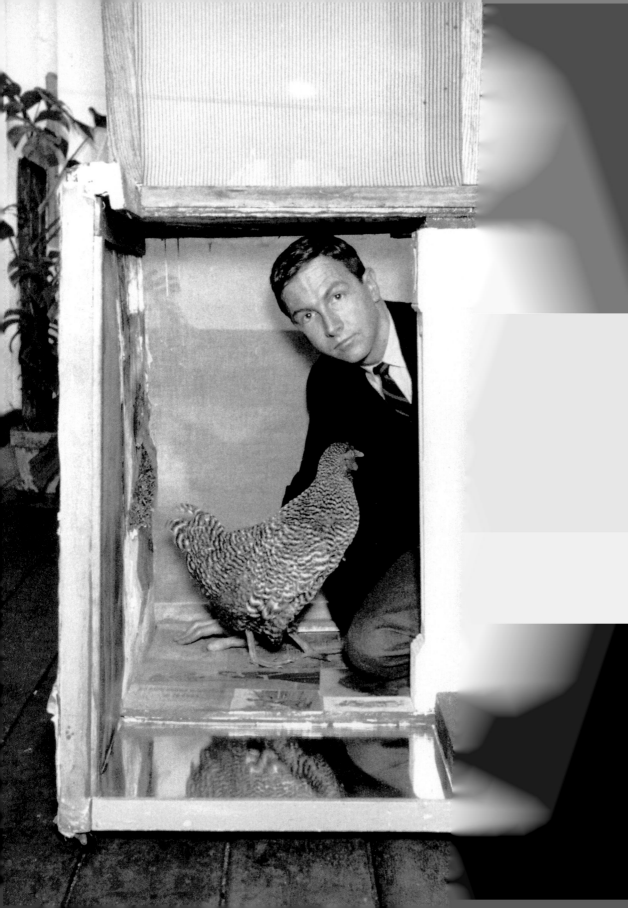

Encounters
with Rauschenberg

This is going to be a frankly personal lecture—as much about me as
about Rauschenberg. And I'll begin by confessing to a little game I
sometimes play while I read—checking off in my mind whatever traits
I have in common with world-famous men. St. Augustine, for instance, ends
one of his letters by regretting that he cannot respond to all his friend's ques-
tions because he's mislaid his friend's letter. "It has somehow or other," he
writes, "gone astray at this end, and cannot be found after long search."[1]

And I say to myself: See? St. Augustine and I cultivate the same sort of
filing system.

Then, the other day, reading the diaries of Franz Kafka, I was struck by
these entries:

June 1, 1912: "Wrote nothing."

June 2: "Wrote almost nothing."[2]

Here I marvel at the close match of our respective work habits.

Finally, there's something I share even with Rauschenberg—I mean the
way he came across at the grand opening of his retrospective, September 18,
1997, at the downtown Guggenheim in New York. Having arrived thirty
minutes late to address some two hundred impatient journalists and a dozen
television crews, even from Mexico to Japan, Rauschenberg announced—"I
don't have anything to say." The very words I too had used when Walter Hopps,
co-organizer of this retrospective, requested this lecture.

1. Robert Rauschenberg with his *Untitled*, c. 1954,
"U.S. Paintings: Some Recent Directions," Stable
Gallery, New York, 1955

Walter's letter, dated July 29, said that what the exhibition organizers and Rauschenberg wanted for the occasion was "a public lecture...on the full spectrum of Rauschenberg's career," and they thought I should deliver it. Why me? Because—the letter went on to say—beginning in the late 1950s I had championed Bob's work, and because I had written about it in the early 1970s.

But, I thought, that was a lifetime ago. Since then, I've been variously distracted, and as for personal contacts, Bob and I have hardly said "Hi" to each other in twenty-five years. So I picked up the phone to convey my regrets.

Unfortunately, something at the back of my mind keeps interfering with better judgment and makes me ask—even as I say No—what I would have done, had I said Yes. And so I told Walter Hopps that the most I could possibly manage, were I to do it, would be to reminisce for half an hour or so about former times, when I knew Rauschenberg slightly; actually talked to him once or twice.

Walter said "Great!"—and thus produced the predicament we are to share these next ninety minutes, while I talk about days of yore, when everybody was young and a New York subway ride cost 5 cents instead of $1.50 and an exotic couple called John and Dominique de Menil were settling into the boondocks of Texas.

My first encounter with Rauschenberg's work was inauspicious. A young man named Hilton Kramer had just invaded New York to become editor of *Arts* magazine, now defunct. He had come out of Chicago and out of literature, bringing with him a keen appreciation of T.S. Eliot and a determination to rid the art world of everything in it that was obviously sham—like Abstract Expressionism.

Because of some theoretical work I had published, Hilton invited me to write a monthly column on the New York gallery scene; and I agreed, though I would prove a bitter disappointment to him. My first piece was a rave review of de Kooning's *Woman* paintings (Fig. 2)—and Hilton was dismayed to see me take that stuff seriously. Next month I covered a group show organized by Tom Hess at the Stable Gallery, December 1955. It displayed recent work by twenty-one young New York painters, some of whom, Joan Mitchell among them, I liked a lot.

Hilton was shocked by my praise of these painters. All he approved of

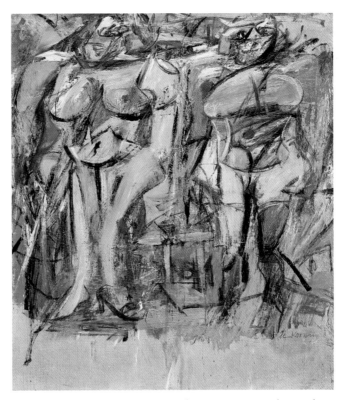

2. Willem de Kooning, *Two Women in the Country*, 1954. Oil, enamel, and charcoal on canvas, 46⅛ x 40¾ in. Hirshhorn Museum and Sculpture Garden, Smithsonian Institution, Washington, D.C., Gift of Joseph H. Hirshhorn, 1966

was my brief dismissal of an entry by one Robert Rauschenberg—not a painting, but an upright contraption, with cut-out pictures pasted on inside and out, and a stuffed American hen in the open box, lower right (Figs. 1, 3). The artist called it a Combine and I dismissed it as follows:

> On the merry work of Robert Rauschenberg the kindest comment I can make is that some of my friends, whose (other) judgments I respect, think it not out of place in an art exhibition.... [I concluded by invoking the great prankster of legend:] Till Eulenspiegel is abroad again, and one must be patient.[3]

These lines were written by a graduate student deep in the study of Romanesque architecture and just starting out as a moonlighting critic. His remarks were meant to sound knowing, faintly condescending, but not wholly unkind.

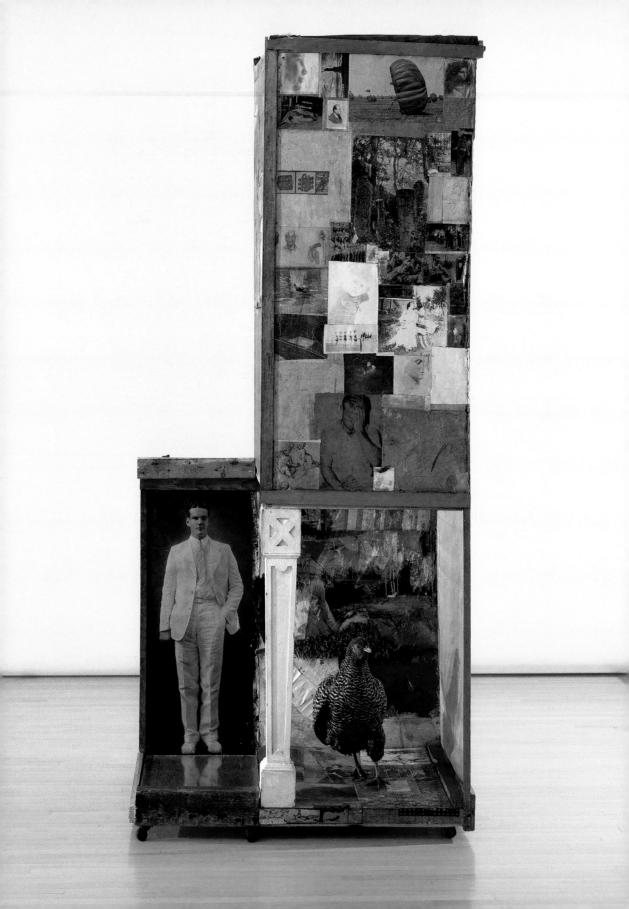

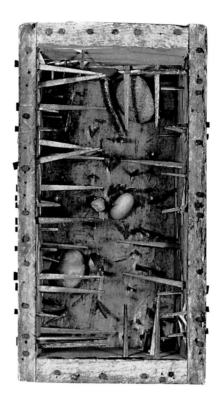

He was in good company. A similar note of benign condescension had been struck by Marcel Duchamp looking at a Rauschenberg *Music Box* at the Stable Gallery about two years before: a rough wooden box filled with nails of different caliber and intended for rattling to produce "clinks and thumps" (Fig. 4). Invited to try it, Duchamp obediently shook the box against his ear; then, putting it down, quoted a familiar musical title: "It seems to me I've heard this song before." Years later, but still in a similar spirit, Robert Motherwell said of Pop Art: "I like to see young artists enjoying themselves." So, when I briefly dismissed Rauschenberg in 1955, I was coming on as a wise elder.

And remember who else was then making art. In 1955, Matisse had just died, but Léger, Chagall, Miró, Giacometti, and Dubuffet were around; Picasso was indestructible; and in America, Pollock, Kline, and de Kooning were making a new kind of painting that demanded attention, hard thinking, and lots of defending if you thought well of it.

I say "defending" because this new abstract painting was then widely denounced, not just in *The New York Times*, but by battalions of prominent artists. I recall three of them ganging up on me at a party for having praised

Philip Guston. Painters of Guston's generation were only just out of their youth, and they still needed advocates. In that embattled moment, it might have seemed disloyal to accept interference from a cadet like Rauschenberg.

My strained relations with Hilton Kramer soon reached the breaking point, and I stopped writing reviews. But I kept looking, and two years later, standing before some new Rauschenbergs at Leo Castelli's gallery, I received what felt like a revelation. Accordingly, in March '58, I dashed off a letter to *Arts*. It read:

> Two years ago, in these pages, I wrote a brief and somewhat scathing paragraph on what I called "the merry work of Robert Rauschenberg." "Eulenspiegel," I concluded, "is abroad and one must be patient." These last four words are all right; the rest I regret. And I want to take this opportunity to say that Rauschenberg's latest show at Leo Castelli's seems to me to include two or three pictures of remarkable beauty.[4]

Rereading this letter now, more than forty years later, I wonder most at its mildness, and am surprised to find it referenced in print by Walter Hopps. Hopps describes the negative criticism Rauschenberg's work was getting during the 1950s—even from "unusually intelligent and knowledgeable observers." And then remarks:

> Virtually not until May 1958, when Leo Steinberg, in a letter to the editor of *Arts* magazine, recanted his previously expressed negative reaction to Rauschenberg's work, did the general tide of adverse opinion begin to change.[5]

This much in historical retrospect. The immediate response to my letter was a chilly note from Hilton Kramer, dated March 26, 1958:

> Dear Leo:
> It pains me to read your Letter to the Editor, and it pains me to publish it, but of course I shall publish it.
> I do hope that this is not the beginning of a series of such letters in which past criticisms are to be footnoted and up-dated.
> > Sincerely,
> > Hilton

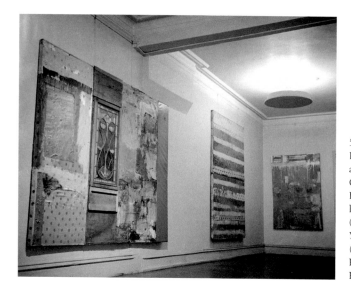

5. Installation view of Rauschenberg's works at the Charles Egan Gallery, New York, December 1954. From left: *Untitled*, 1954 (now dismantled); *Yoicks*, 1954; *Untitled (Red Painting)*, 1954. Photograph by Robert Rauschenberg

Unbeknownst to my correspondent, I had a secret agent in his office, and she leaked to me Kramer's further remark: "This will ruin Leo Steinberg as a critic." He was mistaken: it wasn't the letter that did it.

There were three more responses. First, a note from Alfred Barr congratulating me on having set a great precedent. This really astonished me. Wasn't it the natural thing to do? If you had put down a young artist and then found that there was more to him than you thought, wouldn't you want to straighten the record—for his sake as well as your own?

The next response to my second thoughts was a postcard from a friend, saying: "I saw your humble pie letter in *Arts*." And I thought, "Humble Pie?" Why not rather the opposite? She should have written: "I never saw such conceit! What on earth makes you think that anyone remembers what you wrote years ago, or gives a damn?"

The third response was non-verbal. It took the form of a smile on Rauschenberg's face as I happened to pass him sitting with a couple of friends outside a Greenwich Village café. No words were exchanged.

We had talked briefly just once before—in December 1954, when I saw his *Red Paintings* at the Charles Egan Gallery (Fig. 5). Rauschenberg had previously shown all-white pictures (Fig. 6), and he had done all-black ones. Now he was into red (Fig. 7).

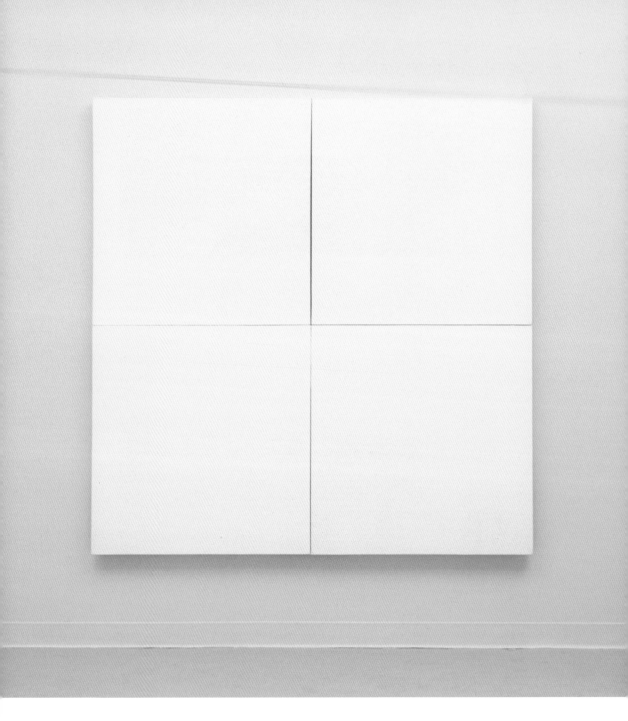

6. *White Painting* [four panel], 1951. Oil on canvas,
72 x 72 in. Collection of Robert Rauschenberg

7. *Untitled (Red Painting)*, 1954. Oil, fabric,
and newspaper on canvas, 70¾ x 48 in.
The Eli and Edythe L. Broad Collection

The show at Charlie Egan's was sparsely attended; not one TV crew. Only two people were there—Bob himself and a young woman of unknown provenance and serious beauty. She stood perfectly still, centered on the gallery floor, looking at one of the pictures.

Rauschenberg came up and said "Hi"; and I—not yet a critic and therefore under no professional obligation to form an opinion of the paintings—offered instead my opinion of the young woman: "What a beautiful girl!" Whereat Bob, with instant enthusiasm: "Yes, and you know I found her myself."

It seemed an odd thing to say. What I *think* Rauschenberg meant was that she was not an artist, or art student, not someone's girlfriend or wife, not gallery staff or art groupie, but a person from out there in the real world, waiting to be found by him and brought in—an *objet trouvé*, so to speak—a living exemplar of what his art was about. And I don't mean the girl, you understand, but the induction process.

Rauschenberg then turned to those all-red paintings and said: "I am always wondering what will look good in a picture. Is it color? So I'm trying that now."

Spoken with a kind of primordial innocence—like a born-again pediatrician checking out what newborn babies might like to eat: "Do you suppose they'd go for milk? So I'm trying that now."

But Bob's remark, so disarming the way he just tossed it off, was far from innocent. Though it seemed bland enough at the time, it was deadly. Because all of Rauschenberg's work questions what it is that looks good in a picture—with devastating effect on ancient orders of privilege. Once that question is posed, it turns out that oils and acrylics come off no better than, say, gold or dirt—Bob had covered both bases (Figs. 8, 9). Where painting presumes no distinction of value between a good-looking smudge and an image, anything goes, anything may get in, even something so outlandish as color. (Well, perhaps not *any*thing; you may notice that trees, for instance, rarely enter Rauschenberg's repertoire, not even in his photography. They do not exemplify, as smudges may, what Oldenburg calls "city nature.")

A party, early fall '61: I was sitting with Rauschenberg and Jasper Johns, and we were talking about the problem young artists face when they find themselves doing what someone else has been doing already. Jasper said, well, you change course and do something else. And then Rauschenberg added: "You see, you don't want to disturb."

8. *Untitled (Gold Painting)*, c. 1953.
Gold leaf on fabric and glue on
Masonite, in wood and glass frame,
12¼ x 12⅝ x 1⅛ in. Solomon R.
Guggenheim Museum, New York.
Bequest of Eve Clendenin, 1974

bottom:
9. *Dirt Painting (for John Cage)*,
c. 1953. Dirt and mold in wood
frame, 15½ x 16 x 2½ in.
Collection of Robert Rauschenberg

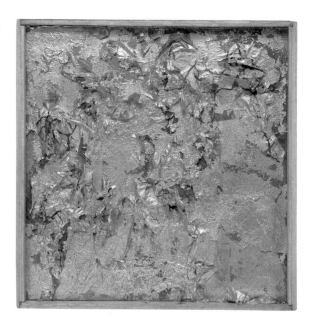

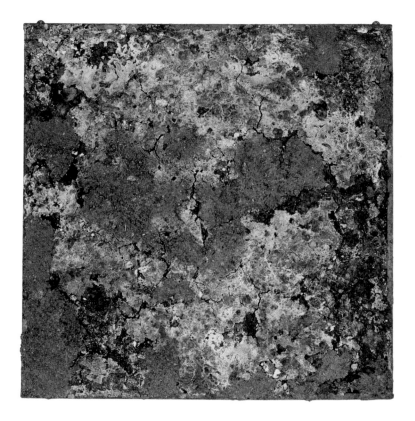

That comment still strikes me as memorable. Bob was saying that you veer away not to escape the charge of being a copycat, but for the sake of the other. He didn't on that occasion spell out what he meant, but I wondered, later that night, just how you would be disturbing someone if you imitated their work. You might, for instance, do the thing better and so make the other look redundant and weak. Bob's remark struck me as unexpectedly ethical, and it stuck.

As I was putting my recollections together for tonight's talk, I suddenly realized that Bob's Do Not Disturb sign sits in an essay I wrote thirty-eight years ago on the young Jasper Johns. The paragraph reads:

> Becoming a painter is like groping one's way out of a cluttered room in the dark. Beginning to walk, he stumbles over another man's couch, changes course to …butt against a work table that can't be disturbed. Everything has its use and its user, and no need of him.[6]

This "can't be disturbed" is sheer Rauschenberg, and I'm glad to acknowledge the debt.

I said just now that Rauschenberg's moral concern for the other surprised me. It shouldn't have. Early in 1955, he was invited to participate in the "Fourth Annual Painting and Sculpture Show" at the Stable Gallery; some younger artists he wanted included were not. So Bob made a Combine— he called it *Short Circuit* (Fig. 10)—which incorporated works by the *refusés*: Jasper Johns and Bob's former wife, Susan Weil. In a sense, he was still questioning what it is that will look good in a painting: a small Jasper Johns *Flag* maybe? a Judy Garland autograph, or a John Cage concert program? It was a fine moral gesture, made possible because his invention of the Combine had given him an appropriate vehicle. Of course, the trick is to perform a moral gesture with wit, and that takes imagination.

To return to the party. Jasper had got up and left, leaving Bob with only myself to talk to. He'd heard from Leo Castelli that I was writing something on Jasper Johns; what was I doing with it?

Well, coming from Jasper's close friend at the time, that's all the prompting I needed. No use telling Bob how the essay analyzed Jasper's paintings. I told him instead of the terrible problem I faced near the end, having posed the rhetorical question: "How improper is it to find metaphorical or emotional content in Johns' work?"

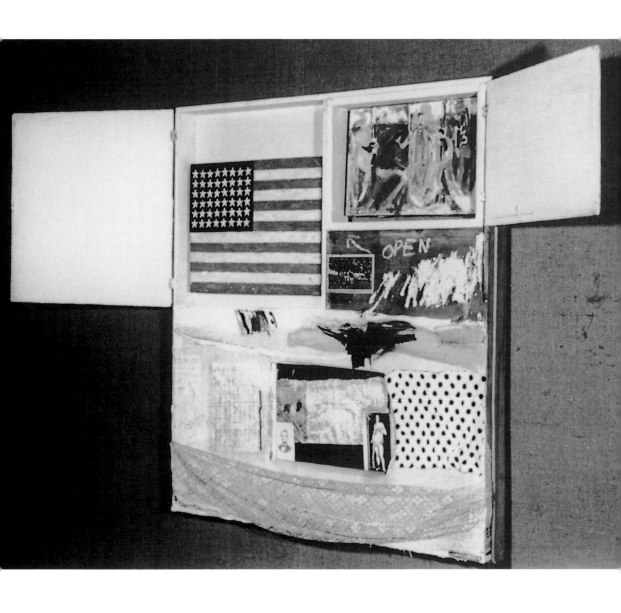

10. *Short Circuit*, 1955. Combine
painting, 49 ¾ x 46 ½ x 5 in.
Collection of Robert Rauschenberg

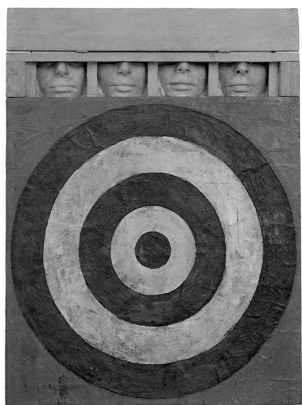

top:
11. Jasper Johns, *Drawer*, 1957.
Encaustic and assemblage on canvas,
30¾ x 30¾ in. Rose Art Museum,
Brandeis University, Waltham,
Massachusetts. Gevirtz-Mnuchin
Purchase Fund, 1963

12. Jasper Johns, *Target with Four
Faces*, 1955. Assemblage, 33⅝ x 26
x 3 in., opened. The Museum of
Modern Art, New York. Gift of
Mr. and Mrs. Robert C. Scull

Remember, we're in 1961, when Johns' claim for his work was deadpan impersonal objectness, and that emotional content was neither overtly nor implicitly present (Fig. 11). This to me seemed mere up-to-date rhetoric—it's how Frank Stella also would talk, and, of course, the gray eminence behind them all, the composer John Cage. Whereas Johns' early work, the longer I looked at it, seemed to grow ever more secretive and confessional; it spoke mutely of solitude, abandonment, desolation. And that put me in a difficult bind, since nothing in the art talk of the day jibed with what I was seeing. And so I blurted it out—and Rauschenberg listened. He listened as few artists will, if you're tactless enough to talk to them about someone else. And when I had done, he said quietly and in dead earnest, "I think you are very close."

Bob won't remember this; nor could he have any idea how that simple phrase of his fortified me to stand up even to Johns himself. When I told Johns that his early works seemed to me to be about human absence, he replied that this would mean their failure for him; it would imply that he had "been there," whereas he wants his pictures to be objects alone.

Well then—I wrote in the essay that came out the following year—"well then I think he fails; not in his paintings, but as their critic." And I proceeded to articulate some of the feeling that I saw emanate from a work such as *Target with Four Faces* (Fig. 12). And Johns said to me, "Well you know, John didn't like that part at all." "John," of course, being John Cage.

Decades later, Jasper came clean. He confessed in a 1984 interview:

> In my early work I tried to hide my personality, my psychological state, my emotions. This was partly to do with my feelings about myself and partly to do with my feelings about painting at the time. I sort of stuck to my guns for a while, but eventually it seemed like a losing battle. Finally one must simply drop the reserve....[7]

That experience confirmed me in a guiding principle of critical conduct: "If you want the truth about a work of art, be sure always to get your data from the horse's mouth, bearing in mind that the artist is the one selling the horse."

And did I abide by my principle? I should say not! My longest conversation with Rauschenberg occurred c. 1957, when I first heard about something outrageous he'd done some years before. And rather than going after the outrage—the horse, as it were—I called the trader.

The work in question was Rauschenberg's *Erased de Kooning Drawing* of 1953 (Fig. 13). The piece had not been exhibited; you heard of it by word of mouth. I did, and it gave me no peace. Because the destruction of works of art terrifies. How could Bob have done it; and why? The work is often, and to this day, referred to as "a Neo-Dada gesture," but that's just a way of casting it from your thought. Obvious alternatives to Neo-Dada suggested themselves at once. An Oedipal gesture? Young Rauschenberg killing the father figure? Well, maybe.

But wasn't it also a taunting of the art market?—an artist's mockery of the values now driving the commerce in modern art? As Rauschenberg said in a recent interview, "Business sure screwed up the art world."[8] And the early fifties is when the screwing up got under way. I recall the *frisson*, the thrill that went through the New York art world at the news that a de Kooning painting had just sold for $10,000. Wow! More than most of us earned in a year. Some fellow artists instantly raised their prices by a few thousand— not in the expectation of sales, but from self-respect.

Among the moderns, it was de Kooning whose work now fetched money. And that he was the best draftsman around, everyone knew. And here was young Rauschenberg saying in effect—so you think it's worth money, do you? And because art translates into money, we ought to cherish the art? And so he proceeds to destroy it, like Cleopatra dissolving a priceless pearl in vinegar to flaunt her disdain of mere treasure.

Someone once pointed out that God shows his contempt for wealth by the kind of people He selects to receive it. St. Francis showed a like disesteem, but contrariwise, giving all he had to the poor. Rauschenberg—assuming the above interpretation correct—would have shown it more economically with a battery of erasers.

But that gave his destructive gesture two motives: the anti-commercial and the Oedipal one. And the two did not seem to agree. Killing the father is not the same as demonstrating contempt for wealth. It would have to be one or the other, unless both hunches were wrong.

So I picked up the phone and called the horse trader himself. And we talked for well over an hour. Occasionally, thereafter, I considered writing up what I remembered of our talk, but then Calvin Tomkins discussed the *Erased de Kooning Drawing* in his Rauschenberg profile in *The New Yorker*,[9] and he did it so well that I thought, "Good, that's one less thing I have to write." But I don't mind talking about it and recalling whatever I can of that phone conversation.

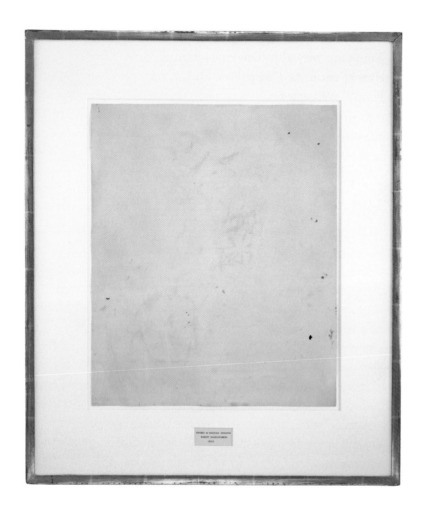

13. *Erased de Kooning Drawing*, 1953. Traces of
ink and crayon on paper, with mat and label
hand-lettered in ink, in gold-leafed frame, 25¼ x
21¾ x ½ in. San Francisco Museum of Modern
Art. Purchased through a gift of Phyllis Wattis

First, being asked how he came to do the piece, Bob said he'd been working with an eraser, using it as a graphic, or anti-graphic implement. But he found that the process always left him depressed, a condition not conducive to work.

So, since the erasure of his own drawing was such a downer, it occurred to Bob that, though there was nothing wrong with the tool he was using, it was seeing his own handiwork fade that depressed him; and that things might cheer up if he erased someone else's. At least that's what he said. And I thought: Okay. A man in touch with his feelings and willing to act on them. But why pick on de Kooning?

I decided to elicit his answer by indirection:

"Would you have done it to a drawing by Andrew Wyeth?"

"No, of course not."

"Why not?"

"Because I don't relate to him."

Ah hah; that might confirm the Oedipal theory; the man you wipe out must be related.

Next question: would he have done it to a Rembrandt drawing? No again, and when I asked, why not, Rauschenberg's answer surprised me. He said: "That would have been too simple."

Now, unfortunately, I cannot remember whether Bob then explained what he meant. I *think* he meant that in erasing a Rembrandt the factor of vandalism would be so overwhelming that nothing else, no other motive, would count for much. In this sense, the gesture would be too one-dimensional, or, as he put it, "too simple." Rembrandt, after all, doesn't make any more drawings, unless by misattribution. Whereas Bill de Kooning was still around making them, lots of them.

So then, complexity of motivation had to be part of the deal. It was not just that effacing someone else's drawing would be less saddening than erasing your own: this other guy had to be someone you knew and admired. And furthermore, the work you destroyed had to be his donation—not only because Bob at the time could not afford to buy a de Kooning, but because the gift, freely surrendered, would convert the transaction into vicarious self-immolation.

Rauschenberg had contrived a tense psychological moment. He was twenty-seven, had been working professionally for only three years, and he was asking the master of the new movement in American painting to collaborate in ritual self-slaughter.

"Why," I asked, "did Bill give you a drawing when he knew your plans for it?"

Bob replied as if the answer were perfectly obvious: "He would not have wanted to hinder me in my work, if that's what I wanted to do."

De Kooning, Bob said, was annoyed, but untied a portfolio of drawings and started rummaging; came up with one, then another, and shoved them back because they were too lightly sketched. Finally chose a particularly dark one in pencil and crayons, saying, "We might as well make it harder for you."[10]

There is another reason, I think, why Bob lit on de Kooning. I live with a de Kooning drawing from the early 1950s—it's of a seated woman, frontal, legs crossed (Fig. 14). The face was drawn, then erased to leave a wide, gray, atmospheric smudge; and then drawn again.

And here is Tom Hess' account of Bill de Kooning's working method. I'd like to read you a paragraph from Tom's book *Willem de Kooning Drawings* (1972), and I'm encouraged to do this by the example of Rauschenberg's *Short Circuit* Combine, which, you remember, brought in some of Bob's friends piggyback. Tom Hess was a friend; hear him describe de Kooning's habit of draftsmanship.

> I remember watching de Kooning begin a drawing, in 1951, sitting idly by a window, the pad on his knee. He used an ordinary pencil, the point sharpened with a knife to expose the maximum of lead but still strong enough to withstand pressure. He made a few strokes, then almost instinctively, it seemed to me, turned the pencil around and began to go over the graphite marks with the eraser. Not to rub out the lines, but to move them, push them across the paper, turn them into planes.... De Kooning's line—the essence of drawing—is always under attack. It is smeared across the paper, pushed into widening shapes, kept away from the expression of an edge.... the mutually exclusive concepts of line and plane are held in tension. It is the characteristic open de Kooning situation...in which thesis and antithesis are both pushed to their fullest statement, and then allowed to exist together....[11]

This much Tom Hess.

In view of such working procedure, one might toy with this further reason why Rauschenberg's partner in the affair had to be de Kooning, rather than Rembrandt or Andrew Wyeth. De Kooning was the one who belabored his drawings with an eraser. Bob was proposing a sort of collaboration, offering—

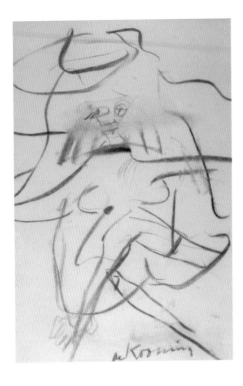

14. Willem de Kooning, *Woman in a Rowboat*, 1953. Charcoal on paper, 9 x 6 in. Collection of Herbert and Paula Molner

opposite:
15. Michelangelo, *Studies for a River God*, 1520–25. Ink on paper, 5 3/8 x 8 1/4 in. The British Museum, London

without having to draw like the master—to supply the finishing touch (read *coup de grâce*).

But no, that's frivolous—even more frivolous than Bob's offhand answer, when I first asked why he had committed this felony.

In an interview with Barbara Rose (1987), Rauschenberg said—and here I trust him—that in his early years, he "loved to draw."[12] It now occurs to me—looking over Rauschenberg's work after 1953—that he hardly draws anymore. Even his brushwork, when he spreads paint on a surface, is never an Abstract Expressionist stroke, which usually forms a trajectory. Rauschenberg's laid-back pigments are the cool substance of paint, never describe anything, refuse to transfigure. In a word, no draftsmanship. And even in 1953, he sensed where he was heading—toward a visual art that had no further use for the genius of drawing. He may himself have begun to use the eraser, not in de Kooning's manner, constructively, but to see drawing expunged.

He was on a perilous course. From Leonardo down to Matisse and de Kooning, drawing had been what Vasari defines as the indispensable common ground of painting, sculpture, and architecture—*disegno*. And now Rauschen-

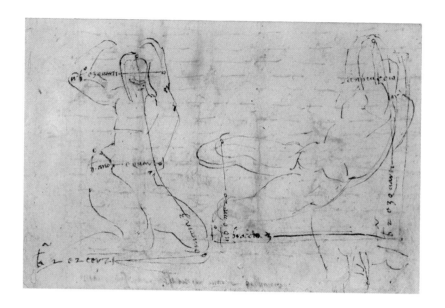

berg says: not in my book. He was expelling from the art of painting what for five hundred years had been its soul; and he wanted de Kooning's consent—implicitly a benediction—to speed him on. He was staging a ritual of supersession that required two parties. As if he could clear the field honorably only with the master's acquiescence and so lay the grounds for new art.

More than thirty years later, Bob explained: "I was trying to make art, and so therefore I had to erase art."[13]

Taken literally, the statement hardly makes sense. Art is not nullified by subtracting one from a thousand de Kooning drawings. Nor, objectively speaking, does the making of art demand that foregoing art be unmade. Rauschenberg's logic makes sense only on the level of metaphor, as a symbolic gesture to mark a personal rite of passage. And perhaps more than that.

L et me suggest what I think the young Rauschenberg's intuition then prophesied.

Here is one of my favorite Michelangelo drawings (Fig. 15)—a quick private notation in which the sculptor records the dimensions of a marble block he had quarried for a River God figure. The work was intended for the Medici Chapel, but never executed.

It takes sharp looking to realize that the two drawings on the sheet are

of the same figure, seen from different angles. And this is what has always filled me with awe: the power of Michelangelo's whirling imagination that enabled him to visualize a complex system simultaneously from two points of view. But this power, which so impressed me ever since my teenage days in art school—this virtuoso capacity for three-dimensional visualization—is now child's play. Given the present resources of computer graphics, anybody can do it at the click of a mouse. The skills of this mouse were not foreseeable to an artist in the early '50s. Yet, it seems to me that Rauschenberg then foresaw the ineluctable obsolescence of the power of mind and hand embodied in this Michelangelo drawing.

His erasure opened the portals of art to all wannabe artists with no talent for drawing. This open-door situation would have arrived anyway, what with digitized animation, video, installation, etc. But Rauschenberg anticipated and legitimized the process from within art. Now the dexterity of the hand may still be admired in piano playing, shoplifting, or knitting, but in the production of images, dexterous draftsmanship is passé. In this sense, Rauschenberg was killing off more than de Kooning.

Meanwhile, Bob and I are still on the phone. And Bob says, "This thing really works on you, doesn't it?" I doubt that he was as interested as I was in pursuing the subject. I think he donated his telephone time in the same spirit that had moved de Kooning to part with a drawing—if that's what I wanted to do, he would not hurry or hinder me.

Finally, I asked: "Look, we've now been talking about this thing for over an hour, and I haven't even seen it. Would it make any difference if I did?" He said: "Probably not." And that's when it dawned on me—it's easy-come now, but the thought had its freshness once—I suddenly understood that the fruit of an artist's work need not be an object. It could be an action, something once done, but so unforgettably done, that it's never done with—a satellite orbiting in your consciousness, like the perfect crime or a beau geste.[14]

Since then, I've seen the *Erased de Kooning Drawing* several times, and find it ever less interesting to look at. But the decision behind it never ceases to fascinate and expand.

It now seems to me that Rauschenberg has repaid de Kooning's gift to him. For though we all know de Kooning to have been a great draftsman, I can think of no single de Kooning drawing that is famous the way some of his paintings are, except the one Bob erased. Famous as the Library of Alexandria is famous, and for the same reason.

Please forgive me for having spent so much time on a negative entity. The erased de Kooning was a one-time exploit, quite unlike the mass of Rauschenberg's work, which revels in visibility. To champion that body of work in its emergence during the 1950s, one had to confront the then-reigning orthodoxy, the rule, or the tyranny, of Clement Greenberg. Remember: performance art, conceptual art, appropriation, environmental and installation art were as yet hardly thought of. They had neither name, nor status, nor likely prospect. The future, according to Greenberg, belonged to Color Field painting. Painting was it, and good painting, in his aesthetic, had to be color coincident with the flat ground—and no concession to extraneous blandishments, such as representation or the titillations of human interest. To Greenberg, one zip by Barnett Newman outweighed all the sentiment of, say, Edvard Munch, whose work, though allowed to be actually moving, must be respectfully relegated to the sidelines, because it failed to boost the millennium of Color Field painting, while Rauschenberg's sideshows were officially dubbed "Novelty Art."

What astonished me then—and still does—is how troops of artists, critics, collectors, and dealers rallied to Greenberg's colors. And I still feel that the chief reason for the enormity of his influence was psychological. He came on with unshakable self-assurance, slowed by no inkling of doubt or uncertainty about an unpredictable future. In a world of enfeebled traditions, only Greenberg knew what was what. So you felt strong in the possession of strong convictions if you sided with Clem. If you did not, you were out.

When William Rubin happened to mention to Clem that I was writing on Jasper Johns, Clem shook his head sadly and said: "How can one be interested in Johns who is so big"—holding his facing palms up 2 inches apart—"when there is Kenneth Noland who is So Big"—arms out at full spread. He had every artist's measure, and, of course, no spare inch for Rauschenberg.

By 1959, I would bring Rauschenberg in whenever I lectured on current art (which I did so much of that a very young niece of mine, asked what her uncle did, said he was a lecherer). In a talk at MoMA in March 1960, I commended Rauschenberg for evading the rhetoric of the day. Giacometti, in an interview with *LIFE*, had said: "If my sculptures become elongated, it is purely involuntary . . . in spite of me they come out like that."[15] Just so, in the New York avant-garde, every self- and Greenberg-respecting

16. Installation view of "Sixteen Americans," The Museum of Modern Art, New York, 1959–60. From left: Rauschenberg's *Satellite* (1955), *Summerstorm* (1959), and *Kickback* (1959)

painter was claiming to paint to the beat of the sacred Unconscious, so that each stroke of the brush landed with the necessity of a natural phenomenon. The artist was the mere medium through which mightier forces asserted themselves. Against this pretension that you worked without the intervention of judgment or choice, young Rauschenberg wonders naively what it is that will look good in a picture. How about this necktie? And in it goes (Fig. 19).[16]

At The Museum of Modern Art in 1960, I went on to cite a point made more than thirty years earlier by the great formalist critic Roger Fry. Fry had written that nothing insults a painter more than your saying, at the sight of his latest landscape, "What beautiful country!" Because, if you care about art, you see formal relations on canvas, not countryside. You're not supposed to regard an outdoors scene by Corot or Cézanne as real estate; you are to look past the subject and see "plastic sequences."

By this test, Rauschenberg was pitiably unartistic, because if you pointed admiringly to a necktie, or a stuffed bird in one of his Combines, or to the paisley cloth in *Hymnal* (Fig. 18), saying "what lovely fabric," Bob would respond with enthusiasm, "Yes, isn't it—I just had to put it in."

My old notes turned up an interesting clipping, dated January 1960—the art critic of *The New Yorker*, Robert Coates, reviewing MoMA's "Sixteen Americans" exhibition (Fig. 16). An entry by Rauschenberg (Fig. 17), one of the sixteen exhibitors, failed to please Mr. Coates:

17. *Satellite*, 1955. Combine painting, 79 3/8 x 43 1/4 x
5 5/8 in. Whitney Museum of American Art, New York.
Gift of Claire B. Zeisler and purchase with funds from
the Mrs. Percy Uris Purchase Fund

18. *Hymnal*, 1955. Combine painting,
64 x 49¼ x 7¼ in. Sonnabend Collection

19. *Levee*, 1955. Combine painting, 55 x 42¾ in.
Private collection

20. *Red Interior*, c. 1955. Combine painting, 56¼ x 60½
x 2⅝ in. Collection of David Geffen, Los Angeles

The picture area, he wrote, is pretty much of a dribble, and [there is a] pheasant mounted on ... top of the canvas. At this writing, the reason for its being there escapes me.[17]

Of course, the first reason for its "being there" is that Rauschenberg liked it. But then a critic might want to know why Rauschenberg liked it enough to let it intrude on this work. And he might learn that the stuffed pheasant resonated for the artist with some childhood memory. But no one pursues such associations until an artist has been acclaimed. Who cares about a man's childhood, if his maturity is of no interest! Research of this kind was unthinkable in 1960.

In May of that year, at Washington University in St. Louis—at the inauguration of Steinberg Hall (no relation)—I told an audience that Abstract Expressionism was history and that the next wave had come in with Rauschenberg and Jasper Johns. It was the last time that I offered anything approaching a market tip, but the sponsors, and then the press, thought I was cuckoo.

Five years later, the tide had begun to turn. Bob had taken the Grand Prize at the Venice Biennale, and when I spoke of him in Louisville, Kentucky, the press was respectful. Among my old notes, I find this clipping, dated April 22, 1965. It reads in part:

> For the bewildered who may still feel that the "combines" and paintings of Robert Rauschenberg are irreverent practical jokes (Fig. 20), a message from Leo Steinberg came through sharp and clear in his lecture at the Speed Museum Thursday night....
>
> Though not of his doing, Steinberg's lecture had for Louisvillians aspects of a lively rebuttal. Another New York critic, Clement Greenberg, speaking at Speed Hall last fall, had no praise, but a sniff, for Rauschenberg. If Greenberg strengthened anti-Rauschenberg feeling, Steinberg's eloquent case is the kind that draws converts....

I'll spare you the rest. What was needed in the mid-sixties was resistance to Clement Greenberg, and I figured that to do it effectively, to champion Rauschenberg, required a special strategy. Mine was to campaign on Greenberg's own turf, on enemy territory, as it were—not in defense of Rauschenberg's subject matter, or kooky procedures, or puckish invention—but on formalist grounds and precisely in terms of the picture plane. A book published in 1972 finally summarized what I'd been saying—and that ended

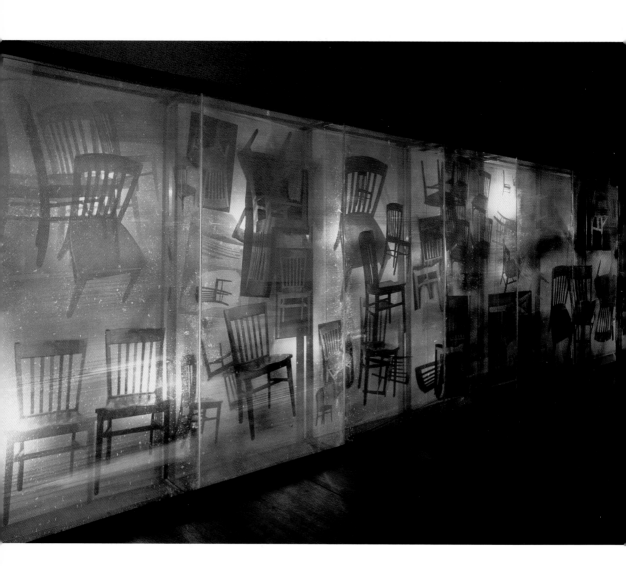

21. *Soundings*, 1968. Mirrored Plexiglas and
silkscreened ink on Plexiglas, with concealed electric
lights and electronic components, 94 x 432 x 54 in.
Museum Ludwig, Cologne

my involvement with Rauschenberg's work, because by then my beard was graying, and I decided that one of the functions of aging is to leave others their chance to be young.

I'd like to read a few passages from what I published in '72 before checking out, even though most of it is now old hat.[18] Take, for instance, my case for the role of the spectator. In Greenberg's then-dominant system, a picture was self-sufficient. I argued that any new art changes its relationship with the spectator, altering—in a phrase I was surprised to find in George Eliot— "altering with the double change of self and beholder." To me, this induced change seemed crucially part of the work. Pictures, I wrote,

> create their own viewer, project their peculiar concept of who, what, and where he is.
>
> Is he a man in a hurry? Is he at rest or in motion? Is he one who construes or one who reacts? Is he a man alone, or a crowd? Is he a human being at all—or a function, a specialized function or instrumentality, such as the one to which Rauschenberg's *Soundings* (Fig. 21) reduced the human agent. (A room-size transparent screen whose illumination was electronically activated by sound; the visibility of the chairs which constituted the image depending on the noises made by the viewers—their footfall when entering, their coughing or speaking voice...)

All this, in our present phase of performance and installation art, will seem obvious enough. And so, perhaps, will my musing on the nature of pictorial surface—for most artists now a moribund issue. The issue was, in fact, deadened around the time my book *Other Criteria* appeared. In 1975, Jannis Kounellis mounted his show at the Sonnabend Gallery (first staged in Rome in '71): the show consisted of the artist himself sitting on a live horse with a mask of Apollo held to his face (Figs. 22, 23). Rumor has it that Clement Greenberg, about to enter the gallery, stopped in the doorway, momentarily stunned; and a gallery staffer, passing the baffled critic, said: "What's the matter, Clem; having trouble with the picture plane?"

Whatever your opinion of such horseplay—I admit that the visual record of it is unimpressive; we have seen nobler steeds—still, Kounellis deserves a bow as the artist who once bewildered Clem Greenberg. And given the date of the Kounellis performance you realize that what I am about to read—from a section of my "Other Criteria" essay headed "The Flatbed Picture Plane"—came, like most criticism, with built-in obsolescence. But this is how I then conceived Rauschenberg's hinging role in art history.

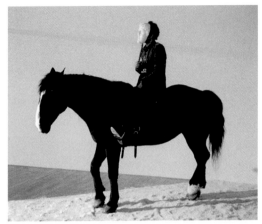

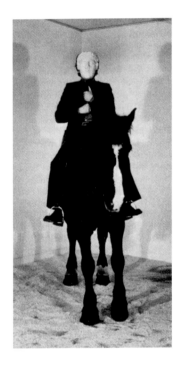

22 & 23. Jannis Kounellis, *Untitled* [with horse], 1975. Performance/installation, Sonnabend Gallery, New York

The Flatbed Picture Plane.

I borrow the term from the flatbed printing press—according to Webster, "a horizontal bed on which a horizontal printing surface rests." And I propose to use the word to describe the characteristic picture plane of the 1960s—a pictorial surface whose angulation with respect to the human posture is the precondition of its changed content.

In the foregoing Western tradition, pictures were conceived as representing a world, some sort of worldspace that reads on the picture plane in correspondence with the erect human posture. The top of the picture corresponds to where we hold our heads aloft; its lower edge gravitates to where we place our feet. Even in Picasso's Cubist collages, where the Renaissance worldspace concept almost breaks down, there is still a harking back to implied acts of vision, to something that was once actually seen.

A picture that harks back to the natural world evokes sense data which are experienced in the normal erect posture. Therefore the Renaissance picture plane affirms verticality as its essential condition. And the concept of the picture plane as an upright surface survives the most drastic changes of style. Pictures by Rothko, Still, Newman, de Kooning, and Kline are still addressed to us head to foot—as are those of Matisse and Miró. They are revelations to which we relate visually as from the top of a columnar body; and this applies no less to Pollock's drip paintings and the poured *Veils* and *Unfurls* of Morris Louis. Pollock indeed poured and dripped his pigment upon canvases laid on the ground, but this was an expedient. After the first color skeins had gone down, he would tack the canvas onto a wall—to get acquainted with it, he used to say; to see where it wanted to go. He lived with the painting in its uprighted state, as with a world confronting his human posture. It is in this sense, I think, that the Abstract Expressionists were still nature painters. . . .

But then something happened in painting—most conspicuously (at least within my experience) in the work of Rauschenberg and Dubuffet. We can still hang their pictures—just as we can tack up maps and architectural plans, or nail a horseshoe to the wall for good luck. Yet these pictures no longer simulate screens rising from base to top, but opaque flatbed horizontals. They no more depend on a head-to-toe correspondence with human posture than a newspaper does. The flatbed picture plane makes its symbolic allusion to hard surfaces such as tabletops, studio floors, charts, bulletin boards—any receptor surface on which objects are scattered, on which data is entered, on which information may be received, printed, impressed—whether coherently or in confusion. The pictures of the last twenty years insist on a radically new orientation, in which the painted surface is no longer the analogue of a visual experience of nature but of operational processes (Figs. 24, 25).

To repeat: it is not the actual physical placement of the image that counts. There is no law against hanging a rug on a wall, or reproducing a narrative picture as a mosaic floor. What I have in mind is the psychic address of the image, its special mode of imaginative confrontation, and I tend to regard the tilt of the picture plane from vertical to horizontal as expressive of the most radical shift in the subject matter of art, the shift from nature to culture.

A shift of such magnitude does not come overnight, nor as the feat of one artist alone. Portents and antecedents become increasingly recognizable in retrospect—Monet's *Nymphéas,* or Mondrian's transmutation

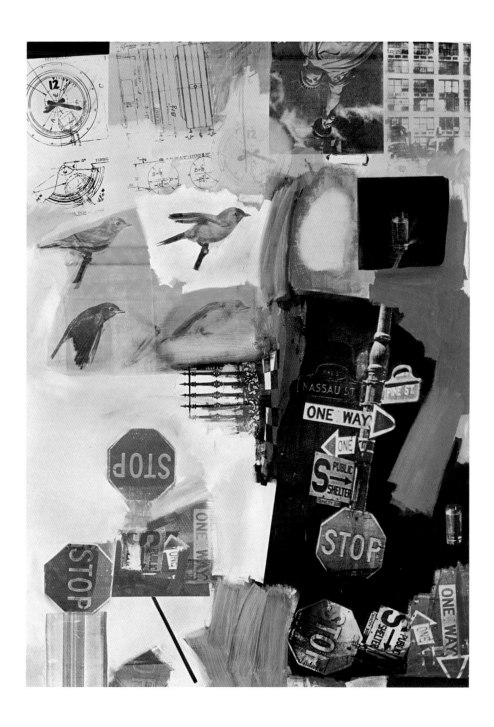

24. *Overdrive*, 1963. Oil and silkscreened ink on
canvas, 84 x 60 in. Private collection, Switzerland

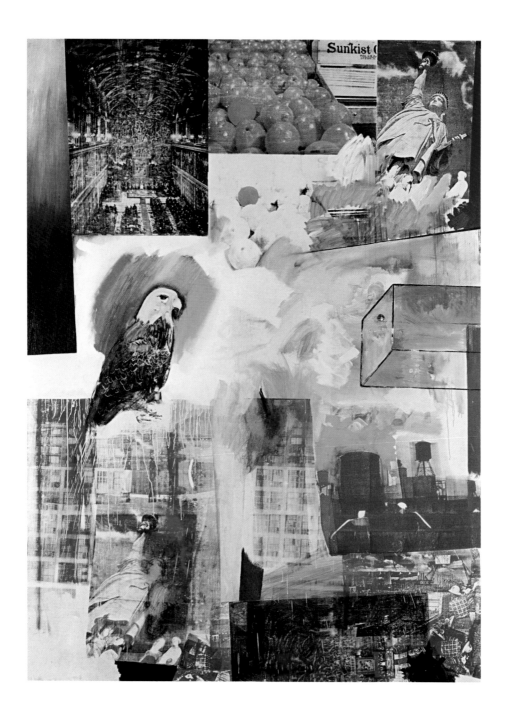

25. *Windward*, 1963. Oil and silkscreened ink on canvas,
96 x 70 in. Fondation Beyeler, Riehen/Basel

of sea and sky into signs plus and minus. And the picture planes of a Synthetic Cubist still life or a Schwitters collage suggest like-minded reorientations. But these last were small objects; the "thingness" of them was appropriate to their size. Whereas the event of the 1950s was the expansion of the work-surface picture plane to the man-sized environmental scale of Abstract Expressionism. Perhaps Duchamp was the most vital source. His *Large Glass*, begun in 1915, or his *Tu m'* of 1918, is no longer the analogue of a world perceived from an upright position, but a matrix of information conveniently placed in a vertical situation. One detects a sense of the significance of a ninety-degree shift in relation to a man's posture even in some of those Duchamp "works" that once seemed no more than provocative gestures: the *Coatrack* nailed to the floor and the famous *Fountain,* a urinal tilted up like a monument. Here one might include even Duchamp's outrageous proposal to "use a Rembrandt as an ironing board"—another ninety-degree shift, this time from nature to anti-culture.

But on the New York art scene the great shift came in Rauschenberg's early work. Even as Abstract Expressionism was celebrating its triumphs, he proposed the flatbed or work-surface picture plane as the foundation of an artistic language that would deal with a different order of experience. The earliest work which Rauschenberg admits into his canon—*White Painting with Numbers* (Fig. 26) was painted in 1949 in a life class at New York's Art Students League, the young painter turning his back on the model. Rauschenberg's picture, with its cryptic meander of lines and numbers, is a work surface that cannot be construed into anything else. Up and down are as subtly confounded as positive-negative space or figure-ground differential. You cannot read it as masonry, nor as a system of chains or quoins, and the written ciphers read every way. Scratched into wet paint, the picture ends up as a verification of its own opaque surface.

In the year following, Rauschenberg began to experiment with objects placed on blueprint paper and exposed to sunlight. Already then he was involved with the physical material of plans; and in the early 1950s used newsprint to prime his canvas—to activate the ground, as he put it—so that his first brushstroke upon it took place in a gray map of words.

In retrospect the most clownish of Rauschenberg's youthful pranks take on a kind of stylistic consistency. Back in the fifties, he was invited to participate in an exhibition on the nostalgic subject of "nature in art"—the organizers hoping perhaps to promote an alternative to the new abstract painting. Rauschenberg's entry was a patch of growing

26. *22 the Lily White* [formerly titled *White Painting
with Numbers*], c. 1950. Oil and pencil on canvas,
39½ x 23¾ in. Collection of Nancy Ganz Wright

grass held down with chicken wire, placed in a box and hung on the wall (Fig. 27). The artist visited the show periodically to water his piece—a transposition from nature to culture through a shift of ninety degrees. When he erased a de Kooning drawing...he was making more than a multifaceted gesture; he was changing—for the viewer no less than for himself—the angle of imaginative confrontation; tilting de Kooning's evocation of a worldspace into a thing produced by pressing down on a desk.

The paintings he made towards the end of the fifties included intrusive non-art attachments: a pillow suspended horizontally from the lower frame (*Canyon*; Fig. 28); a floor-based ladder inserted between painted panels (*Winter Pool*; Fig. 29); a chair standing against a wall but ingrown with the painting behind (*Pilgrim*; Fig. 30). Though they

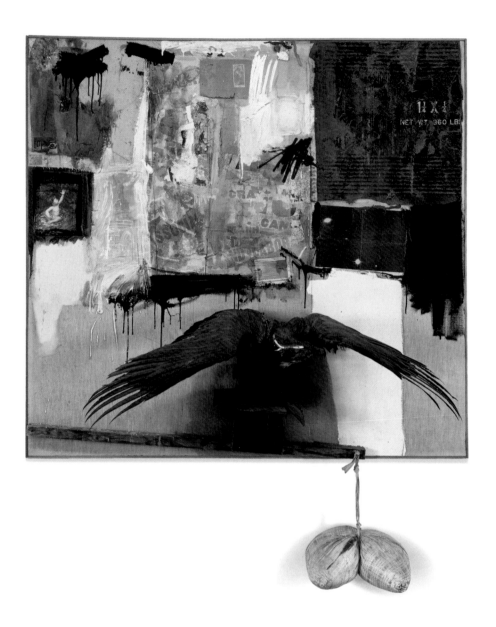

opposite:
27. *Growing Painting*, 1953. Dirt and vegetation
in wood frame, c. 72 x 25 in. Lost or destroyed.
Installation view, Stable Gallery, New York, 1954

28. *Canyon*, 1959. Combine painting,
81¾ x 70 x 24 in. Sonnabend Collection

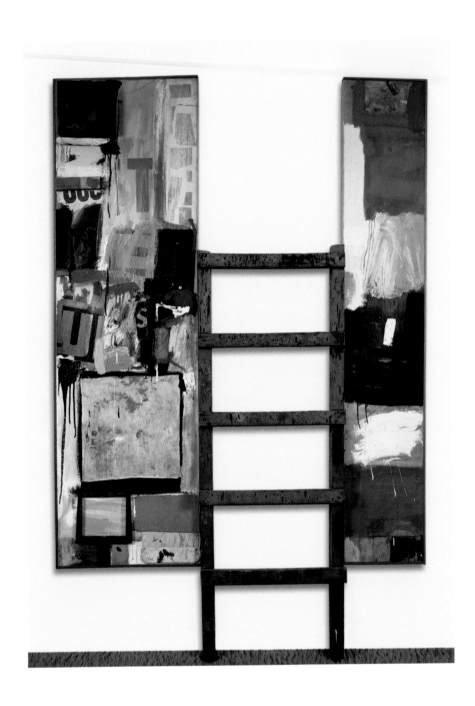

29. *Winter Pool*, 1959. Combine painting, 90 x 59 1/2 x 4 in.
Collection of David Geffen, Los Angeles

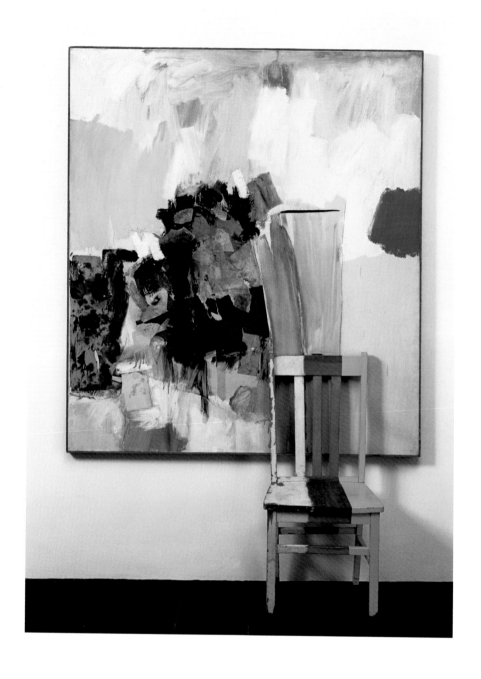

30. *Pilgrim*, 1960. Combine painting, 78 ¾
x 56 ¼ x 17 ¾ in. Hamburger Kunsthalle

hugged the wall, the pictures kept referring back to the horizontals on which we walk and sit, work and sleep.

When in the early 1960s he worked with photographic transfers, the images—each in itself illusionistic—kept interfering with one another; intimations of spatial meaning forever canceling out to subside in a kind of optical noise. The waste and detritus of communication—like radio transmission with interference; noise and meaning on the same wavelength, visually on the same flatbed plane.

This picture plane, as in the enormous canvas called *Overdraw*

31. *Overdraw*, 1963. Oil and silkscreened ink on two canvases, 60 x 120 in. Kunsthaus Zürich

(Fig. 31), could look like some garbled conflation of controls system and cityscape, suggesting the ceaseless inflow of urban message, stimulus, and impediment. To hold all this together, Rauschenberg's picture plane had to become a surface to which anything reachable-thinkable would adhere. It had to be whatever a billboard or dashboard is, and everything a projection screen is, with further affinities for anything that is flat and worked over—palimpsest, canceled plate, printer's proof, trial blank, chart, map, aerial view. Any flat documentary surface that tabulates information is a relevant analogue—radically different from the

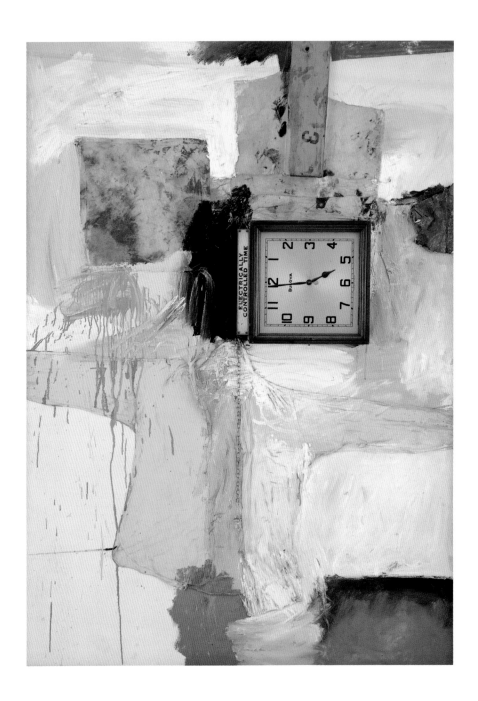

32. *Third Time Painting*, 1961. Combine
painting, 84 x 60 in. Collection of Ann
Tenenbaum and Thomas H. Lee, New York

transparent projection plane with its optical correspondence to man's visual field. And it seemed at times that Rauschenberg's work surface stood for the mind itself—dump, reservoir, switching center, abundant with concrete references freely associated as in an internal monologue—the outward symbol of the mind as a running transformer of the external world, constantly ingesting incoming unprocessed data to be mapped in an overcharged field.

To cope with his symbolic program, the available types of pictorial surface seemed inadequate; they were too exclusionary and too homogeneous. Rauschenberg's imagery needed bedrock as hard and tolerant as a workbench. If some collage element, such as a pasted-down photograph, threatened to evoke a topical illusion of depth, the surface was casually stained or smeared with paint to recall its irreducible flatness. The "integrity of the picture plane"—once the accomplishment of good design—was to become that which is given. The picture's "flatness" was to be no more of a problem than the flatness of a disordered desk or an unswept floor. Against Rauschenberg's picture plane you can pin or project any image because it will not work as the glimpse of a world, but as a scrap of printed material. And you can attach anything whatsoever, including paint, so long as it bedded down on the work surface. The old clock in Rauschenberg's 1961 *Third Time Painting* (Fig. 32) lies with the number 12 on the left, because the clock face properly uprighted would have illusionized the whole system into verticality—like the wall of a room, part of the given world. Or, in the same picture, the flattened shirt with its sleeves outstretched—not like wash on a line, but—with paint stains and drips holding it down—like laundry (or like Duchamp's Rembrandt) laid out for pressing. The consistent horizontality is called upon to maintain a symbolic continuum of litter, workbench, and data-ingesting mind.

Perhaps Rauschenberg's profoundest symbolic gesture came in 1955 when he stood his bed against the wall and smeared paint on it. There, in the upright posture of "art," it continues to work in the imagination as the eternal companion of our other resource, our horizontality, the flat bedding in which we do our begetting, conceiving, and dreaming. The horizontality of the bed relates to "making" as the vertical of the Renaissance picture plane related to seeing.[19]

I once heard Jasper Johns say that Rauschenberg was the man who in this century had invented the most since Picasso. What, I think, he invented was a pictorial surface that let the world in again. . . .

33. *Bed*, 1955. Combine painting, 75¾ x 31½ x 8 in. The Museum of Modern Art, New York. Gift of Leo Castelli in honor of Alfred H. Barr, Jr.

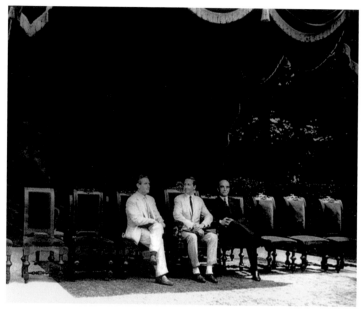

34. Rauschenberg (middle) and officials at the Grand Prize in Painting presentation ceremony, XXXII Esposizione Biennale Internazionale d'Arte, Venice, June 19, 1964

W hat sort of world? Judging by the critical fortunes of *Bed* (Fig. 33), a world of the ordinary, yet somehow perplexing enough to arouse passions and generate myth.

On July 10, 1964, *LIFE* magazine—to whose art editor, Dorothy Seiberling, I was then married—ran a story on "the lanky Texan" who had just won the Grand Prize at the Venice Biennale (fig. 34).

The piece was headed "Europe Explodes as American Takes Prize," and it reported as follows:

> The judges wrangled for three days, then declared Rauschenberg winner over some 500 artists from 34 countries. The award brought forth European headlines of TREASON AT VENICE and blasts at the American's "grotesque pieces of junk and trash cans...." The Patriarch of Venice ordered Catholics to stay away from the show because works like Rauschenberg's "offended human dignity." The artist himself calmly accepted the $3,200 prize. He had already explained his *Bed*: "I think of it as one of the friendliest pictures I've ever painted. My fear has always been that someone would want to crawl into it."

TIME magazine took a different view. An article on the artist, entitled "Most Happy Fella," reproduced *Bed* full-page in color, with a caption reporting (presumably on the artist's say-so) that "BED was made during a lean period in 1955, when Rauschenberg had nothing to paint on. Viewers may suspect vestiges of ax murder."[20]

This raises two questions.

1. *Nothing to paint on?* So Rauschenberg told it again to Barbara Rose more than thirty years later. Had he come to believe his own legend? Unable to afford canvas in '55, and no place to lay his paint on, he could have frescoed his walls and ceiling, following respectable precedent. The poverty plea to explain why the bed was preferred strikes me as deflective PR. The jolt one might feel at seeing a bed so ill-used is softened by the tale of the Indigent Artist, a romantic standby of such tenacious banality that we give it instant assent. Assenting, we hardly notice how perversely the "explanation" reduces Rauschenberg's involved bedding to inconsequential neutrality, as if *Bed* were a paint surface like any other, a ground that might as well have been a blank canvas, if only the artist that day had not been out of pocket. (History does not record where Bob slept that night, or how soon his bed was replaced.)

2. *Vestiges of ax murder?* So even Leo Castelli—Rauschenberg's dealer who had purchased *Bed* in 1958 and in 1989 donated it to The Museum of Modern Art—described it in a 1984 interview: "A real pillow and quilt heavily splattered with paint, in which some horrible act—a rape or murder—seemed to have occurred."[21] The charge still hangs on. *American Visions* by Robert Hughes describes *Bed* as "so slathered in red paint that it might have been the site of an ax murder."[22] And Francine Prose, reviewing the Rauschenberg retrospective for the *The Wall Street Journal*, described *Bed* as "a quilt, sheet and pillow slathered with paint . . . it suggests the scene of a grisly crime or sexual encounter. . . ."[23]

This is in tune with the Zeitgeist, but out of sync with the picture. For thirty-odd years critics have sought to nudge *Bed* into confessing vice or atrocity, hoping to move it from its own startling presence to a more familiar scenario of antecedent horror, homo or hetero. So the dribbled red paint and fingernail polish beneath the pillow are said to suggest freshly spilled blood, because they are red. But why stop at one color? Why overlook the similar drips of blue paint to the right? What would a conscientious sleuth deduce from *that* clue? Recognize it, perhaps, as the gore of someone blue-blooded,

shed by a second victim, this one of royal lineage; while all that dripping white paint might indicate a lactating princess. You see, the plot thickens; Rauschenberg's "friendly" piece becomes quite a thriller.

As for that ardent sex act, I note that the bed is a single bed, remarkably narrow, just wide enough for one pillow. So if *Bed* makes you think of sexual abuse, it allows only for self-abuse. But even that seems ruled out, since the quilt coverlet, the lower half of the picture, is undisturbed, spread smooth as on a bed neatly made. It signals no recent occupant; and there goes your thriller.

Besides, all the paint trickles down, so that it must have been applied when the thing was already in upright position. In other words, not like a bed receptive to weary limbs, but like a panel to dripping paint.

Please don't think me prudish on this account. Like the rest of the nation, I cherish murder and transgressive sex as great entertainment. I just miss them in Rauschenberg's *Bed*.

And by the way, having reexamined the work, I have more reason to doubt the legend of the destitute painter deprived of canvas and resorting at last to his sleeping accommodation. The work consists of bedding and pillow carefully nailed to—the 1997 catalogue says to a board, but it looks to me like stretched canvas. Either way, no actual bed. Meanwhile, the smears and drips work here pretty much as they do elsewhere in Rauschenberg. They are what you see—drips and smears. Red paint reeks no more of bloodshed than white invites crying over spilled milk. Therefore, I cannot agree with Robert Hughes, who sees "the crusty pigment" in *Bed* as "a manifesto of impurity and violence."

Questioning Rauschenberg's output for likely meanings, I would, if possible, distinguish works produced in solitary from those done in collaboration. *Bed* looks private to me, hence, perhaps, more resistant to interpretation, which may be what makes it so irresistible to interpreters. Let's take one more stab at it.

You remember Rauschenberg's oft-quoted remark that he wants to operate in the gap between art and life. In between. Can we make the interval spanning these spaced-out poles palpable? What would a concretion of that gap look like?

I would begin by reflecting that art, for an artist, is not primarily what museums curate, but what he is doing, day-in, day-out. In his routine, art

equals work, so that art and life interpenetrate. If Rauschenberg's remark puts these terms in opposition, he must have in mind life situations when he's not actually on the job—answering the phone, paying his bills, accepting prizes, or living it up and at last dozing off. Only in this sense does "life" in Rauschenberg's dictum oppose itself to the notion of "art," the two as distinct as work is from distraction, from interruption, or from sleep, rest, repose.

Now imagine Rauschenberg up late and still working, catching sight of his bed and foreseeing himself stretched out on it, or better still, snuggled inside. "My fear," he said, "has always been that someone might want to crawl into it." We take that "someone" to be someone else, but the speaker need not be excluded. It is he, after all, who nightly crawls into it, letting go of his art to cross the divide which, he says, his art wants to engage.

In Rauschenberg's *Bed*, as I see it, the art/life distinction appears in collapse. Since it's an artist we are talking about, I propose to identify paint, the deposition of pigment, as the witness of his professionalism, his working token of art. And let *Bed* stand for life lived in moments other than work; it's where he naps and goofs off. (I am aware that some folks, like Marcel Proust, work in bed, but for a painter, the bed is not typically the workplace.) And now Rauschenberg's *Bed* abrogates the distinction between work and non-work, between work and whatever stoppage or dalliance a bed may be host to. The artist has crunched what custom and discipline keep apart. Life and art abed in shocking cohabitation.

The question may now be rephrased: when Rauschenberg uprights his couch into the posture of Art and daubs it with paint, what is he doing? He is not, I think, soiling the bed and propagating "impurity." (To an artist, oil paint is not a pollutant.) I rather see him collapsing a notorious oscillation, i.e., the periodicity of our circadian round. On the one hand, the phases of life passed in bed, on the other, his wakeful activity (application of paint)— these are no longer estranged but at one. Rauschenberg is consummating the nuptials of Life and Art by mating their kinds, and without prejudice to their respective identities.

Whether this happy outcome exhausts *Bed*'s inner meaning is questionable. The proposed iconography sounds too rational. But it at least keeps in sight what we are visually given, instead of having us muse on absentee cutthroats and murderees and encouraging fantasies about body fluids red, white, and blue. Nor need we worry about reducing the work to lucidity. If my patter makes it sound logical, the picture, being a Rauschenberg, doesn't

look it. Its deposits of paint—never descriptive or representational—signify only as the signature of the painter, the mark of his passage. In the present instance, they leave behind unresolvable paradox. Dripping oil paint is the last thing you want on a bed—well, then, the last shall be first. And a bed vertical is a contradiction in terms. Contradictory too is the conflation of private and public, for what is more private than your sleeping retreat, or more public than your place on a gallery wall? Rauschenberg is coaxing opposites to cohabit. Perhaps that is why he called *Bed* one of his "friendliest" pictures.

The message, then, is neither violence nor impurity, neither holy poverty nor sexual mayhem, but simply—Rauschenberg passed this way, unmaking distinctions.

Of course, the life-art distinction doesn't hold in the long run. Rauschenberg's *Bed* now hangs on a MoMA wall—art all the way. But the work was a happening once, a conceptual piece. It served the artist as a ritual performed, a private closure of that famous art-or-life gap.

So here we are, forty years on, gathered at this demure retrospective of Rauschenberg septuagenarian, and your revenant, rubbing his eyes, returned to the scene of an earlier enthusiasm after a quarter century's slumber.

To catch up on things, he reads the reviews, noting a massive shift from formalism, picture planes, Cubist grids, color fields, etc. to iconography and the decoding of symbols. How then should he deal with a Rauschenberg *Bicycle*, whose every contour is outlined with neon tubing (Fig. 35)? It luminates. Why, what's the point?

A resourceful critic might want to give the thing meaning—*pour l'approfondir*, if he were French, and perhaps Roman Catholic. The artist, you see, is investing the bicycle with a halo. As if to suggest not only—as John Cage wrote about Rauschenberg in 1961—that "beauty is now underfoot," but that even holiness is; and that in Rauschenberg's leveling, a bicycle is as sacrosanct as any saint's tooth in a reliquary.

Well, that would make it a meaningful statement, but I wouldn't buy it. I would rather relate that neon surround to earlier Rauschenberg practice, as when he surrounds a dangling car key with a wide swath of pale blue (Fig. 36). I see such framing as the mark of personal appropriation, taking possession of objects he likes, or claims to be his—like Vasari, the first collector of master

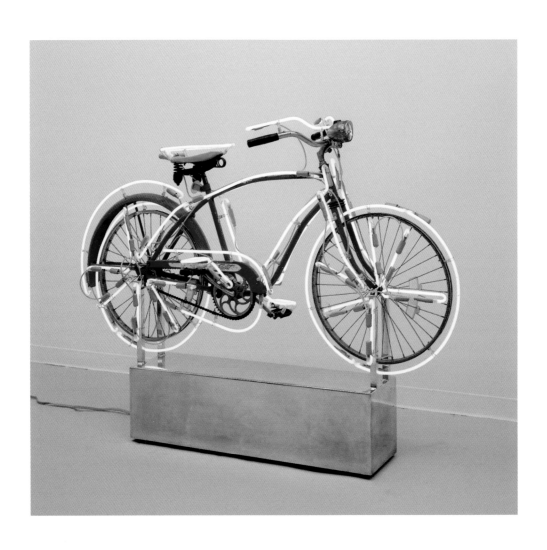

35. *Rocket/ROCI USA*, 1990. Neon tubing and
quartz light on bicycle, mounted on aluminum base,
54 x 74 x 24¾ in. Collection of Robert Rauschenberg

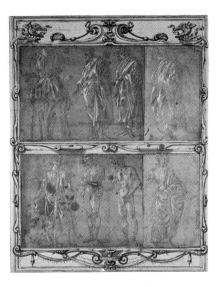

36. *Breakthrough II*, 1965. Color lithograph on paper, 48⅜ x 34 in. Universal Limited Art Editions, West Islip, New York

37. Filippino Lippi, *Figure Studies*. Metal-point heightened with white on paper, 8⅛ x 16 in. each sheet, set into framing surround by Giorgio Vasari. Christ Church Picture Gallery, Oxford

drawings, who surrounded each select item with a hand-drawn cartouche to accession it for his own (Fig. 37). Except that Rauschenberg does it with inversion of traditional reverence. High-culture icons lose caste. What is raised on a pedestal, arrayed in light, is the bicycle.

But this again verges on meaningful interpretation, the trap set for us by so much of this work. Rauschenberg iconography has become a field to be mined, an expanding minefield. We shall have dissertations galore, including perusals of the fine print in the newspaper scraps that abound in Rauschenberg's pictures. Undoubtedly, many secrets will be exploded, mostly with respect to the artist's sexual orientation.

Last fall, a sensitive article on Rauschenberg in *The New York Times*, written by Martin Duberman, discussed the growing awareness, since about 1980, of Rauschenberg's same-sex iconography. The author argues that the homoerotic symbols in the work matter crucially to an understanding of Rauschenberg's art.[24]

That tokens of covert self-revelation are scattered throughout no one denies. But Duberman's opposition of private and public may need refining to admit esoterica, signals aimed at an inner circle. Such insider allusions become

interesting to a wider public only to the extent that the artist is. Once he is famous, the work is minutely searched—not to find what makes it deserving of fame, but because celebrity incurs this kind of attention.

Let me try to explain by way of one outstanding example—Rauschenberg's Combine of 1955–59, which he called *Monogram*—the infamous stuffed Angora goat with the automobile tire about its midriff (Fig. 38). The animal stands on what jesting Rauschenberg called its "pasture"—a square platform, mounted on casters, covered with collage elements. So the goat stands on a work of art. To say it like Cage: "Art is now underfoot."[25]

When I first saw the goat—nearly forty years ago, before it migrated to Sweden—I wondered briefly whether any of the components, flat or 3-D, spelled a coherent theme. There was a collaged child's footprint, small wheels under the board, a rubber tire, and a newsphoto of (I think) a helicopter or parachutist—all surrounding that famously sure-footed beast. What follows? Since modes of transportation always fascinated the artist, was he perhaps thinking of the evolution of travel—from walking, to the invention of the wheel, to motoring, to aviation? You'll be glad to hear that this copious hypothesis collapsed in two seconds. You can Rorschach this sort of thing into the work, but then it's the next patient's turn.

Now Martin Duberman, in that *New York Times* article, argues that Rauschenberg's work is loaded with encoded messages, same-sex iconography, gay signifiers; and that these "once revealed"—I quote his conclusion— "rip off the masks and challenge the prescribed formulas that have tyrannized our understanding, letting all sorts of alive things breathe at last."

How does this prospect apply to *Monogram*? In an excellent review of the Rauschenberg retrospective by Mark Stevens in *New York* magazine, *Monogram* is called—"a rude sexual joke."[26] Here Stevens seems to endorse an interpretation of *Monogram* that surfaced in print almost two decades ago, when Rauschenberg's tired goat was over twenty. In 1981, Roger Cranshaw and Adrian Lewis published, in the British journal *Artscribe*, a perceptive essay entitled "Re-Reading Rauschenberg." Observing that automobile tires serve symbolically in subsequent Rauschenberg works and performance pieces, the authors wrote:

> *Monogram* is a particularly excellent example of the semantic loading of the tyre as signifier. The bizarre silhouette of the goat is contrasted with the geometric regularity of the tyre. The goat's static rootedness is contradicted by the tyre's dynamic associations.... [E]xoticism (Angora

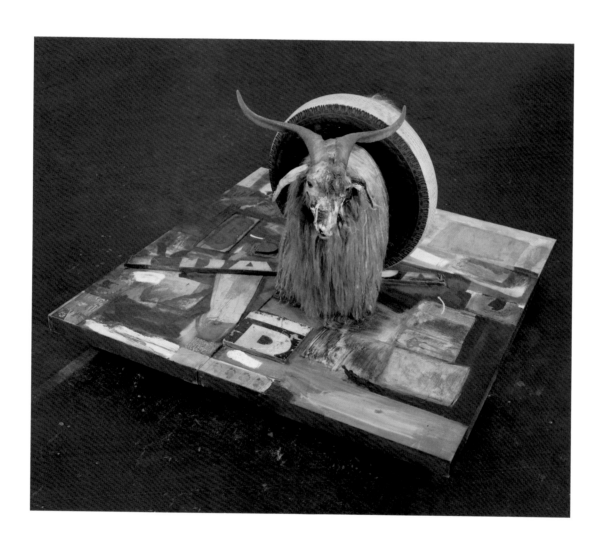

38. *Monogram*, 1955–59. Combine, 42 x 63¼ x 64½ in.
Moderna Museet, Stockholm

goat) is compromised by banality (tyre).... At another level, the goat penetrates the tyre as orifice. Again, however, we are faced with an inversion of the norm, since the goat, clad in its shaggy fleece, appears soft relative to the erect rigidity of the tyre. We have suggested that the goat inside the tyre can be read as a sign of sexual penetration.[27]

Here follows a footnote, in which Cranshaw and Lewis acknowledge that such unilateral reading contradicts a general principle of Rauschenberg's practice. In the artist's own words: "If I see any superficial subconscious relationships that I'm familiar with—clichés of association—I change the picture."[28] The footnoted quotation is intended to caution against taking the homosexual denotation too literally. But it's probably too late to rescind. Robert Hughes had already aired his reading of *Monogram* in *The Shock of the New* (1981):

> Goats are the oldest metaphors of priapic energy. This one, with its paint-smutched thrusting head and its body stuck halfway through the encircling tyre, is one of the few great icons of male homosexual love in modern culture: the Satyr in the Sphincter....[29]

More recently, in *American Visions*, Hughes reiterates, calling Rauschenberg's tire-girt goat a "sexual fetish."

> *Monogram* remains the most notorious of Rauschenberg's combines: a stuffed Angora goat...girdled with a tire. The title is self-fulfilling: it is Rauschenberg's monogram, the sign by which he is most known. But if one asks why it became so famous, the answer can only lie in its power—funny but unsettling too...— as a sexual fetish. The lust of the goat, as William Blake remarked, is the glory of God; and this one, halfway through the tire, is an image of anal sex, the satyr in the sphincter.[30]

This is strong and seductive prose—especially deft in enlisting both Blake and God at just the right moment. Yet I find the proposed reading too reductive to persuade. In place of an ever-astonishing incongruity, we are given the notion of a close fit. For what Rosalind Krauss calls an "uncontainable network of associations,"[31] we are offered one overwhelmingly single meaning, making the work and its motivations—as Rauschenberg put it on an earlier occasion—"too simple," too single-minded. The thrill generated in Rauschenberg's work of the fifties by the unpredictable, the perilously uncontrolled, the indeterminate connotation, has been replaced by one naughtiness—excitement of a different order.

Hughes is a writer I admire,[32] but must we believe that anal sex is what *Monogram* signifies? Consider the genesis of the piece. Rauschenberg had bought the stuffed goat in a Manhattan used-furniture store in 1955 for $35, not certain as yet how he would use it.

What made him buy it? It may or may not be relevant that Bob keeps a sad memory of a pet goat he had as a child in the Texan oil-drilling town where he grew up; and of his weeping when, returning from school, he found that his father had wantonly slaughtered his pet.

Robert Hughes cites the story in connection with *Monogram*. But if it was this childhood trauma that resurged at the sight of the goat in the Manhattan furniture store, then Hughes' linkage of goat and priapic energy seems inappropriate. In fact, Arthur Danto offers a very different association:

> Utterly familiar as tires and goats are—so familiar that they could be images in an alphabet book for children (T is for tire, G is for goat)—no one had ever seen a goat wreathed with a tire before, as in Rauschenberg's signature work, *Monogram*. Who could say what it meant? The goat is, to be sure, a sacrificial animal, so it is entirely thinkable that it would be wreathed with laurel when led to the altar. *Monogram* is an exceedingly evocative and at the same time a very funny work. Who knows what Rauschenberg was thinking? All one knows is that nothing like it had been seen in the entire history of art, and that goat and tire had identities so strong as to counteract any tendency to think of them as other than what they were.... The power and absurdity of the combination suggests that his gifts of adjunction surpassed entirely his—our—capacity to interpret.[33]

Well then, are we seeing "a symbol of priapic energy"; a memento of childhood loss; a sacrificial animal wreathed; or material identities too strong to be anything other than what they are?

The great Cabalist scholar Gershom Scholem was speaking of Kafka when he offered his notion of the canonical: that kind of text which through its intrinsic character compels endless exegesis.[34] It is in this and no weaker sense that *Monogram* assumes canonical status.

Having bought his stuffed Angora goat, Rauschenberg tried on and off for some years to use it in various combinations (Figs. 39, 40, 41).[35] The thing needed mating; what would partner it? Would an intrusive ladder (as used later in *Winter Pool*, Fig. 29) be incongruous enough? No, the intrusion needs to be irremovable, closer, more intimate. Well, then, gird the beast with a tire

39. *Monogram: Preliminary Study I,*
c. 1955. Pencil on paper, 11⅞ x
8¾ in. Collection of Jasper Johns

40. *Monogram,* c. 1958. Combine,
c. 85 x 30 x 36 in. Second state
(dismantled) shown in Pearl Street
studio

41. *Sketch for Monogram,* 1959.
Watercolor, pencil, fabric, and
crayon on paper, 19⅛ x 11⅜ in.
Collection of Robert Rauschenberg

and make it art by mounting it on a standard plinth, rumpwise against an
upright collage. In this arrangement (Fig. 40), the Combine does indeed
look respectably statuesque, quite a museum piece. But it was not until the
following year, four years after the purchase, that Rauschenberg found the
satisfactory combination. According to the retrospective catalogue, it was Jasper
Johns who suggested planting the hooped animal upon a picture-pasture
laid on the floor. So underpropped, so attired, the goat was declared *comme
il faut* and the piece given a name.

Is the title a clue? The catalogue of the Rauschenberg retrospective states
that "the title results from the union of the goat and tire, which reminds
Rauschenberg of the interweaving letters of a monogram."[36] Similarly,
Arthur Danto: "The combination reminded the artist of a monogram, with
the tire as O. Hence the title." But on inquiry, the matter turns hazy: no extant
record has Rauschenberg saying that the tire-goat combination reminded
him of intertwined letters.

What he did say to Walter Hopps is somewhat different. Discussing the

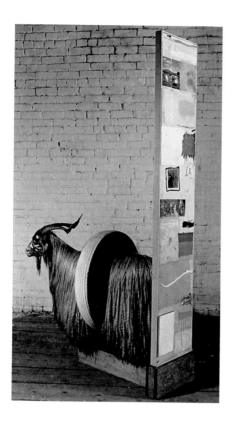

alliance of goat and tire, Rauschenberg said, as if the point were self-evident, that it recalled a monogram ring—not any ring, but one that might include ligatured letters personal to the wearer. This gloss seems to analogize the tire-goat combination to a ringed finger, but it is hard to believe that the artist—ignoring horns, shag, and hooves—thought his goat comparable to an impaling shaft. More likely that the title refers to his own consummating appropriation, his ringing the animal's trunk the way a betrothed finger is ringed. Thus the goat got entitled to commemorate the moment of its investiture, which reminded the artist of a ring circling a finger.

But as Mark Stevens observes of *Monogram*: "It is, before anything else, funny." Danto calls it "a very funny work"; Hughes calls it "funny, but unsettling, too."

Think how much funnier the work would have seemed forty years ago, before it became an international icon. When first assembled, it must have been joked about among Rauschenberg's friends. And it is my hunch that some of these friends, high on liquor and ribaldry—or, as Milton puts it,

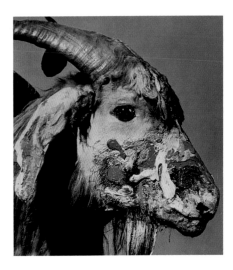

42. *Monogram* (detail), 1955–59.
Combine, 42 x 63¼ x 64½ in.
Moderna Museet, Stockholm

"flown with insolence and wine"—produced the phallic association to im-
prove on the finger: an insider joke, made *ex post facto*, and discounting, for
the joke's sake, those fierce horns and the historical fact that the goat never
passed through the tire but got encircled.

Suppose the joke cracked around 1960. Since then, the Zeitgeist has
donned a new aura, and what would have begun as a closeted in-joke is now
blithely outed—to the delight of iconographers who need meanings to thrive.
But iconographers have many options. Italophiles might notice that the
goat's muzzle has paint on it, and that the pigments used are predominantly
red, white, and green (Fig. 42), which are the colors of Italy, where Rauschen-
berg and Cy Twombly had been traveling just two years before the goat was
acquired. This Italian connection might give an opening to researchers
whose scholarship inclines more to Italy than to sodomy.

It depends on the baggage you bring. A Colonial New Englander, taking
the goat to be pilloried, might have wondered, paraphrasing King Lear (II, 4,
198), "How came my pet in the stocks?" Modern Haitians with memories of
rough popular justice might recall the use of gasoline-soaked automobile
tires as ignitable "necklaces." Friends I have listened to find the nexus of
goat and tire poignant and tragic, the poor beast in straits, beset by indus-
trial waste. Or is it a hula hoop? Myself, trapped in old habits of formal
analysis, look at the respective directions of goat and tire—the goat facing
hither, the tire, given its normal roll, running at right angles to it. In other
words, the interlocked elements at cross-purpose, so that their misalliance

43. Installation view of "Robert Rauschenberg: A Retrospective," Solomon R. Guggenheim Museum, New York, 1997. From left: *Pneumonia Lisa (Japanese Recreational Clayworks)*, 1982, and *Able Was I Ere I Saw Elba (Japanese Recreational Clayworks)*, 1985

suggests duress, rather than gratification. But here I go again, abstracting directional vectors the way I once abstracted verticality and horizontality from Rauschenberg's *Bed*.

In a more serious vein, I tend to see the imposition of the tire as another act of appropriation. It was the tire (sporting a narrow band of white paint) that converted the store-bought, second-hand goat into a Rauschenberg asset and made it private, like a monogram ring. As the artist would later encircle a car key with paint, and a bicycle with neon tubing, so here—to make it his own. The goat alone—even with signature paint on its muzzle—did not look Rauschenbergian enough, until joined with its tire in definitive incongruity.

If some now reverse the process to declare the goat the penetrant agent—like a cork plugging a bottleneck or a finger passed through a ring or your car clearing a tunnel—if analogical thinkers now connect such goings-on with sexual congress, bully for them. As Motherwell might have said: "We like to see young iconographers enjoying themselves." But in my view, *Monogram* is ill-served by the sphincteral interpretation, which strikes me as a retroactive impoverishment inflicted on Rauschenberg's work. I prefer the formulations offered in 1981 by Cranshaw and Lewis: "We are faced with an abundance of competing semantic possibilities"; and again, in one elegant summary: "The works invite decodification, but frustrate its operation."

The influence of dumbing-down iconography is bound to affect future criticism, and may have already seduced the artist himself to propound in his work more flatly readable correlations. Wherever I see this happen, I feel that something of Rauschenberg's unique gift has been traded in for the commonplace of mere meaning.

The New York Guggenheim venue of the 1997–98 retrospective displayed—as in a three-sided chapel—three large works of the early eighties called *Japanese Recreational Clayworks*: huge high-colored, high-fired ceramics that cheerily mutilate Old Master paintings (Fig. 43). High-priced hijinks generated by money to burn.[37]

To my eye, Rauschenberg's three chosen paintings are too strong for the banter he puts them to; I see them prevail, defeating their mocker. On one wall, a work called (I dislike saying it) *Pneumonia Lisa*—the Mona Lisa fourfold (Fig. 44), except that in one of the four, the face of Botticelli's Venus displaces the Leonardo. Not a good move; an unfunny gesture too trite to be interesting. And why, once again, that same well-worn smile? Why pick on the face that launched a thousand slips to add yet another? It's one thing to salvage a throwaway newsprint reproduction of *Mona Lisa*, as Bob used to do when he was poor (Fig. 45). But Rauschenberg, bless him, has prospered. So now the Leonardo face is expensively reproduced, full color, full size—

left:
44. *Pneumonia Lisa (Japanese Recreational Clayworks)*, 1982. Transfer on high-fired Japanese art ceramic, 32 ¼ x 86 ½ in. Collection of Robert Rauschenberg

right:
45. *Untitled [Mona Lisa]*, c. 1952. Collage, 9 ½ x 7 ½ in. Private collection

and it radiates. Despite the accosting paint, I see the Renaissance image still unpossessed, winning hands down.

Speaking of hands. The second panel (Fig. 46) is called *All Abordello Doze*; "all aboard—bordello"—get it? The panel cannibalizes Courbet's lesbian sleepers at the Petit Palais, Paris (Fig. 47). I know you're supposed to look at the ass, but, if you can take the distraction, do look at the way Courbet draws women's hands.

I mention the ass because this feature, excerpted, turns up twice more in the third of this group (Fig. 48), a huge, high-gloss "recreation" dissing Napoleon and his painter, Jacques-Louis David. Rauschenberg's piece mocks David's icon of 1800 (Fig. 49), wherein the young Bonaparte appears crossing the Alps for the conquest of Italy. Single-handed, of course.

In this third *Recreational Claywork*, called *Able Was I Ere I Saw Elba* (God, I hope Bob is innocent of these titles), J.-L. David's image of the heroic rider is intermixed with a predictable excerpt from Courbet's sleeping nudes, the ass cleaving at upper right, and the same prize again, upper center, so that now the hero's hand, instead of pointing to Alpine summits, or to manifest Destiny, targets an alternative destination—a gag worthy of a twelve-year-old.

But the artist must know that. Is it his top-secret message that what the conqueror really goes for is pussy? Or that a heterosexual orientation aimed

46. *All Abordello Doze 2 (Japanese Recreational Clayworks)*, 1982. Transfer on high-fired Japanese art ceramic, 53⅛ x 52½ in. Collection of Robert Rauschenberg

47. Gustave Courbet, *Sleep*, 1866. Oil on canvas, 53⅛ x 78¾ in. Petit Palais, Musée des Beaux-Arts de la Ville de Paris

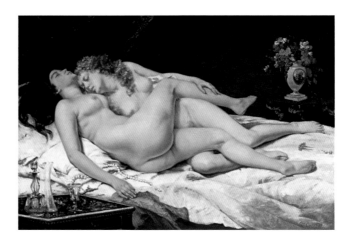

48. *Able Was I Ere I Saw Elba (Japanese Recreational Clayworks)*, 1985. Transfer on high-fired Japanese art ceramic, 106¼ x 91 in. Private collection

49. Jacques-Louis David, *Bonaparte Crossing Mont Saint Bernard*, 1800. Oil on canvas, 102⅜ x 87 in. Château de Versailles et de Trianon, Versailles

at a female crotch is essentially immature? Or that a high-school snicker is no less worthy of celebration than a great feat of arms? Or that the manufacturer of this high-flying crud had it coming?

Whatever the artist's intention, the work settles at a level of meaning so shallow that I'm almost tempted to revert to the dismissive sentiment I published in 1955 about the prankster in Rauschenberg. Meanwhile, I suspect that much of the later work I have trouble responding to may be collaborative.

As you can see, there are stops in this huge retrospective where my admiration for Rauschenberg falters. But were I to pursue this line, you might as well have had Hilton Kramer deliver this lecture.

Thirty years ago, I wrote joyously that Rauschenberg's art "let the world in again." Whether this was an altogether good thing largely depends on what you think of the world. If Hamlet was right to exclaim, "Fie! 'tis an unweeded garden," then there might be some merit in such earlier art as kept the world at a distance, or sifted its contents before letting it in.

But this may be the cracked voice of senectitude. My present distance from Rauschenberg was borne in on me when I read, in his latest interview, that he loves television and keeps it on (without sound) all the time. I don't own a set.

I stopped in renewed admiration before a very large picture of 1990 called *Washington's Golden Egg* (Fig. 50)—looked at it a long time; more than once. Reproductions of it are no good—you have to confront its full breadth, including your own interfering self as it reflects and distorts in the stainless steel slab, nearly 16 feet wide.

To the left, a crumpled sheet of aluminum slides off the main panel, bearing away the vestige of a transferred photograph of a once-elegant Corinthian colonnade; now crushed the way you'd crush a brown paper bag. Who, or what, totaled this metal, or to what end, if any, would be interesting to know. You vaguely wonder what happened. But why I should think this an interesting question puzzles me even more. Perhaps because this exiting feature, now bound for the dumpster, bears away so much preexistence—so much cultural drift, all the way from the invention of the Corinthian column to the compactor. It's the apogee it has reached, its garbage status, that makes it disposable.[38]

Nearby, near center, stands Rauschenberg's loyal hen—unscathed and

monumental enough to trivialize Corinthian columns. What might be its *raison d'être ici?*[39] A revelation of avian nature to embarrass the sorry culture at left? Nonsense; this chicken started out stuffed. Bob accessioned it, took its picture, and silkscreened the product, manipulating its size and color, printing it in monochrome green. The chick is no less an artifact than the colonnade, or, as Shelley rightly observed, "Bird thou never wert." And just to drive the point home, the same poultry—a doppelgänger reduced and printed in red—struts in another file, systems away to the right.

The redoubled fowl polarize about a stack of four superposed photographs, inked in dissonant hues and unrelated to one another. Finally, against the right margin—a tapered strip of flavescent paint, actually brushed on by hand, like in the old days: it recalls the strips with which Jules Olitski formerly margined his paintings—paintings once hailed by the vatic Clem Greenberg as ensuring the perpetuity of Color Field painting.

The end result is the kind of picture which Hilton Kramer, reviewing the Rauschenberg retrospective for the *New York Observer*, execrated as incoherent and vacuous.[40] But this misses the point. It's like complaining that ambiguity is two-faced, or that indirection isn't forthright enough. The point is that we stare at a no-hen's-land wherein nothing neighbors.

In its openness, scale, and shiny precision, a picture like *Washington's Golden Egg* obviously differs from the intimate disarray of Rauschenberg's earlier works. But it distills from their chaos the principle of disconnection. Its parts are immiscible—which means, according to Webster, "incapable of mixing or attaining homogeneity." (Non-chemists find few occasions to use the word, and I thank Rauschenberg for this rare opportunity.)

The picture blazons the incompatible, parades it with such boldface illogic that Near and Next admit no felt neighboring, only disjunction by juxtaposition. The more closely pressed, the keener the dissociation. Items estranged by adjacency, like renters in urban apartments, or travelers, economy class. Where Rauschenberg's earlier work had tended to jumble things in what seemed a random mêlée, a work such as *Washington's Golden Egg* "solders close impossibilities,"[41] abstracts with unfeeling candor the rule of alienating togetherness.

Of course, this triumph of the Immiscible accuses the world, epitomizes experience; could even light the mind into self-recognition. Because consciousness, whether inner- or outer-directed, seldom presides over the kind of connectedness that high art used to idealize.

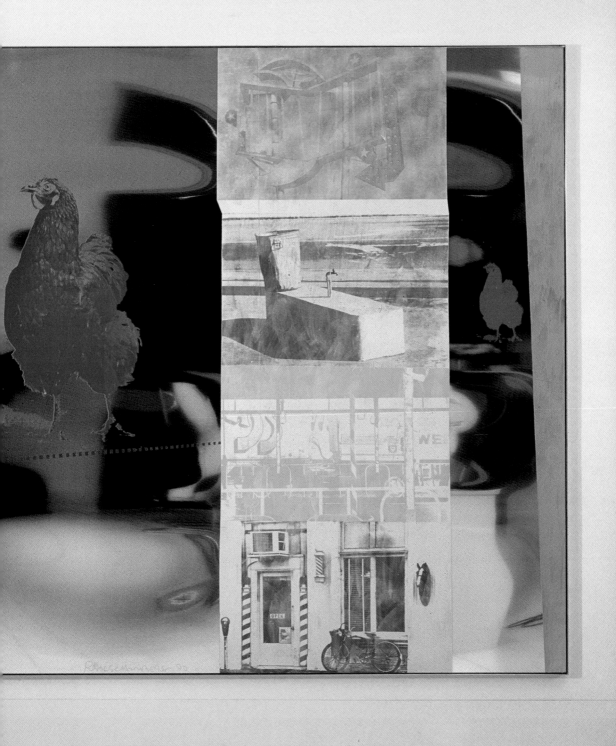

One ideal human condition is companionship, conviviality: imagine two people sitting opposite one another, knees touching, on facing chairs. It takes Rauschenberg's monumental irony to raise this precondition for a convivial tête-à-tête to the summit of impossibility. I refer to his stepped-pyramid pile that culminates in a tryst of contentedly thwarted chairs (Fig. 51).

"Contentedly thwarted" is gibberish, isn't it? What thwarts a chair; what contents it? What puts two seats at once in both states? Only Rauschenberg knows—and entrusts his news to the speechless dialect of the Combine. I suspect a substrate of disappointment in Rauschenberg, of which the recurring motif of unoccupied chairs may be one expression—never more expressive than here. The more these homely amenities approach one another, the more they disallow seating. And as they peak, the irony deepens. Two vacant chairs, made to be sat in and made for each other, appointed to complement one another's frustration. They can't even copulate—all they can do is abut. Mated for instability, they look hoist enough to collapse, but we know they won't. Moment to moment, Rauschenberg's arch construction reinherits stability. His coupled chairs hover high-throned, bestowing dependency on each other, seat-to-seat, partnered in emptiness and mutual repulsion. A match visibly made in heaven or thereabouts.

Rauschenberg assembled the piece in 1981 and called it *The Ancient Incident*. I'm glad to have seen it.

pp. 68–69:
50. Robert Rauschenberg in collaboration with Saff Tech Arts, Oxford, Maryland. *Washington's Golden Egg/ROCI USA (Wax Fire Works)*, 1990. Acrylic, enamel, and fire wax on mirrored aluminum and stainless steel, 96 ¾ x 189 ½ x 13½ in. Collection of Robert Rauschenberg

51. *The Ancient Incident (Kabal American Zephyr),*
1981. Wood-and-metal stands and wood chairs,
86 1/2 x 92 x 20 in. Collection of Robert Rauschenberg

NOTES

1. St. Augustine, letter to Bishop Evodius, c. 414, in *St. Augustine, Letters*, trans. Wilfrid Parsons, New York, 1953, III, no. 163.

2. Franz Kafka, *Diaries, 1910–13*, ed. Max Brod, New York, 1948, p. 263.

3. "Month in Review," *Arts*, 30 (January 1956), pp. 46–47.

4. *Arts*, 32 (May 1958), p. 9.

5. Walter Hopps, *Robert Rauschenberg: The Early 1950s*, exh. cat., Houston, The Menil Collection, 1991, p. 159.

6. Leo Steinberg, *Other Criteria: Confrontations with Twentieth-Century Art*, New York, 1972, p. 21. (The pseudo-generic "he" in the quotation betrays its early date.)

7. From an interview originally published in *Vanity Fair*, 1984; reprinted in *Jasper Johns: 35 Years*, Leo Castelli, New York, 1993, n.p. Cf. Vivien Raynor, "Jasper Johns: 'I Have Attempted to Develop My Thinking in Such a Way That the Work I'm Doing Is Not Me,'" *Art News*, 72 (March 1973), p. 22. Raynor quotes Johns saying that he had worked so as "not to confuse my feelings with what I produced. I didn't want my work to be an exposure of my feelings." As to the nature of those feelings, it is now clear that my own halting interpretation of them—the best I could do in 1961—has been powerfully superseded by (among others) Kenneth E. Silver. See Silver's brilliant and wise "Modes of Disclosure: The Construction of Gay Identity and the Rise of Pop Art," in Russell Ferguson, ed., *Hand-Painted Pop: American Art in Transition, 1955–62*, exh. cat., The Museum of Contemporary Art, Los Angeles, 1992, p. 183.

8. *The Art Newspaper*, no. 73 (September 1997), p. 17.

9. Calvin Tomkins, "Profile: Moving Out," *The New Yorker*, February 29, 1964.

10. The actual erasing proved to be exceedingly difficult, requiring, according to Rauschenberg's recollection, fifteen types of eraser and a full month at hard labor.

11. Thomas B. Hess, *Willem de Kooning Drawings*, Greenwich, Connecticut, 1972, pp. 16–17.

12. Barbara Rose, *Rauschenberg*, New York, 1987, p. 51.

13. Ibid.

14. I experienced the thought again in 1960, watching Jean Tinguely's *Homage to New York*, his self-destructing machine in the garden of The Museum of Modern Art. But Tinguely was seeing his own Rube Goldberg contraptions dismantle and total themselves, which made the devastation psychologically simpler. Simpler still is "the ritual erasing" described in the following paragraph in a recent book by Amanda Vail (*Everybody Was So Young. Gerald and Sara Murphy: A Lost Generation Love Story*, New York, 1998, p. 100): "... the first dada *manifestation* at the Palais des Fêtes on January 23, 1920 ... was a kind of multimedia performance-art happening that included a reading and literary discussion by André Breton, Louis Aragon, and Philippe Soupault; a recitation by Tristan Tzara of the entire text of a newspaper article he had chosen at random, accompanied by clanging cowbells, clattering castanets, and rattles; and the ritual erasing, by Breton, of a chalk painting by Francis Picabia that hung amid an installation of work by Fernand Léger, Juan Gris, and Giorgio de Chirico. The audience, whose initial befuddlement at the proceedings had given way to frustration and rage, went wild, whistling, hissing, and hurling insults at the delighted dadaists."

Breton's performance bears no more relation to Rauschenberg's than a tantrum does to a tantra.

15. *LIFE*, September 1, 1959.

16. The necktie in Rauschenberg iconography—and in the wider artistic culture of the period under discussion—still awaits its requisite scholarly treatment.

17. *The New Yorker*, January 2, 1960, p. 60.

18. The passages quoted below are taken from the title essay in Steinberg, *Other Criteria*, pp. 81–90.

19. This paragraph, dealing briefly with *Bed*, was recycled from a lecture given at New York's Metropolitan Museum in 1965, entitled "Rauschenberg's *Bed*."

20. *TIME*, September 18, 1964, p. 82.

21. Quoted in Alan Jones and Laura de Coppet, *The Art Dealers*, New York, 1984, p. 91. But Castelli continued: "Or so we thought at the time. Now it [i.e., Rauschenberg's *Bed*] seems very mild, very beautiful."

22. Robert Hughes, *American Visions*, New Haven, 1997, p. 517.

23. Francine Prose, "Artifacts of the Age of Anxiety," *The Wall Street Journal*, September 25, 1997, p. A20.

24. Martin Duberman, "Is There Room for Privacy on the Canvas?", *The New York Times*, September 7, 1997, sect. 2, p. 89.

25. Cage's pronouncement is ambiguous, whether or not so intended. "Beauty is now underfoot" can mean either that beauty is ubiquitous as the ground, or that it's now trampled on.

26. Mark Stevens, "More Is More," *New York*, September 29, 1997, pp. 54–56.

27. Roger Cranshaw and Adrian Lewis, "Re-Reading Rauschenberg," *Artscribe*, no. 29 (June 1981), p. 47.

28. The passage is quoted from Dorothy Seckler's interview with Rauschenberg, *Art in America*, 54 (May–June 1966), p. 76.

29. Robert Hughes, *The Shock of the New* (1981), New York, 1987, p. 335.

30. Hughes, *American Visions*, pp. 517–18.

31. Rosalind Krauss, "Perpetual Inventory," in Walter Hopps and Susan Davidson, *Robert Rauschenberg: A Retrospective*, exh. cat., Solomon R. Guggenheim Museum, New York, 1997, p. 215.

32. Robert Hughes has never written a boring sentence; he wouldn't know how.

33. Arthur Danto, "Robert Rauschenberg," *The Nation*, November 17, 1997, p. 32.

34. Quoted in Robert Alter's review of Mark Harman's translation of *The Castle*, *The New Republic*, April 13, 1998, p. 36.

35. The phases of *Monogram* are documented in the *Robert Rauschenberg: A Retrospective* (pp. 554–57), and I am grateful to Susan Davidson, co-organizer of this retrospective, for putting up with my questions.

36. *Robert Rauschenberg: A Retrospective*, p. 557, s.v. "1959."

37. A Japanese manufacturer was apparently marketing full-scale ceramic reproductions of famous pictures at $100,000 apiece.

38. Deleted, because of this lecture's *longueur,* is the history implied: 1) the Corinthian column, the most evolved of the classical orders; 2) the column multiplied into colonnade and engaged to a wall; 3) revival in the High Renaissance; 4) worldwide academic diffusion; 5) discovered by Rauschenberg to be photogenic; 6) his print of it transferred to aluminum; 7) the product crumpled like so much waste; 8) exit.

39. Cf. Christian Morgenstern's wonderful poem "Das Huhn" (1905), about a misplaced hen at a railroad station.

40. Hilton Kramer, "Glub, Glub! We're Awash in Trashy Rauschenbergs," *The New York Observer*, September 29, 1997, pp. 1, 31.

41. Shakespeare, *Timon of Athens*, IV, 3, 388.

Photography

*(Sources and photographers are listed by figure numbers.
All other photographs courtesy of the owners.)*

Peppe Avallone: frontispiece

Harry Bartlett: 11

Ben Blackwell: 13

Copyright © The British Museum, London: 15

Rudy Burckhardt, courtesy of Yvonne Jacquette Burckhardt:
 16, 40

Chris Carone: 45

The Governing Body, Christ Church, Oxford: 37

Bevan Davies, New York: 41

Fondation Beyeler, Riehen/Basel: 25

Edward Fry: 23

Paula Goldman: 3

David Heald: 6, 19, 35

David Heald © The Solomon R. Guggenheim Foundation,
 New York: 8

Hirshhorn Museum and Sculpture Garden, Smithsonian
 Institution, Washington, D.C.: 2

G. Holzer: 50

Kunsthaus Zürich: 31

Ellen Labenski © The Solomon R. Guggenheim Foundation,
 New York: 43

Leo Castelli Gallery, courtesy of Robert Rauschenberg Studio: 10

Robert E. Mates and Paul Katz: 42

Moderna Museet, Stockholm, Sweden: 38

J. P. Mottier, Lausanne, Switzerland: 24

Copyright © 2000 The Museum of Modern Art, New York: 12, 33

Courtesy of Otsuka Ohmi Ceramics Company: 44, 46, 48

Beth Phillips: 32

Pierrain © Photothèque des Musées de la Ville de Paris: 47

Robert Rauschenberg: 5, 27

Rheinisches Bildarchiv Köln: 21

Seymour Rosen: 4

J. Schormans © Photo RMN – Arnaudet: 49

Harry Shunk: 34

Sonnabend Collection: 18, 28

Glenn Steigelman, New York: cover, 51

Jim Strong: 39

Universal Limited Art Editions: 36

Copyright © Elke Walford, Hamburg: 30

Ed Wergeles: 1

Copyright © 2000 Whitney Museum of American Art: 17

Dorothy Zeidman: 9

Senior editor, The University of Chicago Press: Susan Bielstein
Curator, Robert Rauschenberg studio: David White
Archivist/Rights and reproductions, The Menil Collection: Geraldine Aramanda

Designer: Don Quaintance, Public Address Design
Production assistant: Elizabeth Frizzell

Printing: Cantz, Ostfildern-Ruit, Germany
Color separations/halftones: C+S Repro, Filderstadt, Germany
Typography: Composed in ITC Berkeley

Leo Steinberg is Benjamin Franklin Professor Emeritus at the University of Pennsylvania. He has published several books, including *Other Criteria: Confrontations with Twentieth-Century Art* and *The Sexuality of Christ in Renaissance Art and in Modern Oblivion*. His latest book about Leonardo da Vinci's *Last Supper* will be published in 2000.